William Merritt Chase

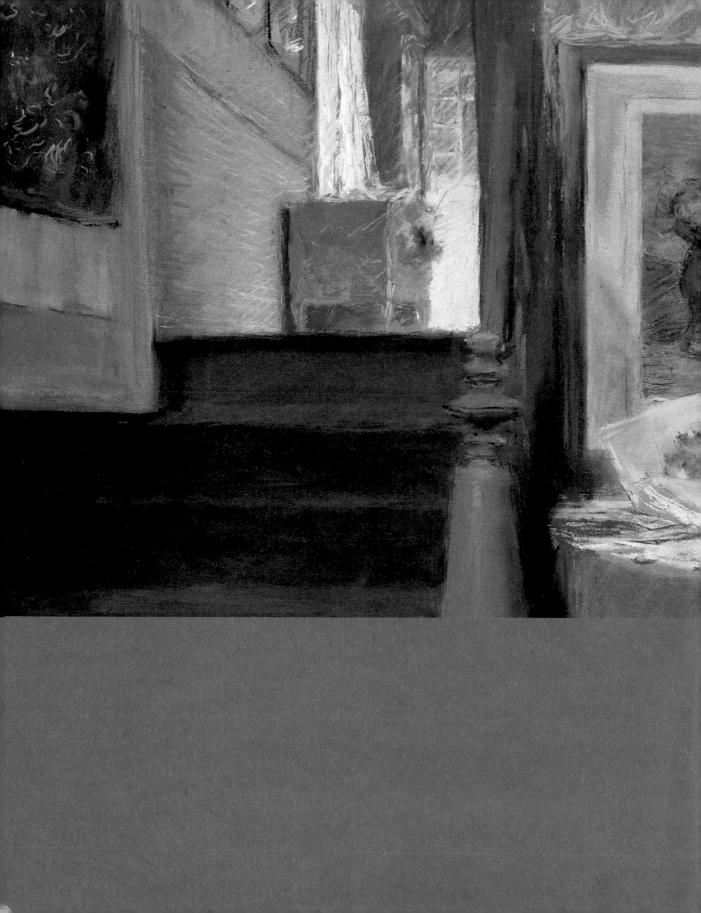

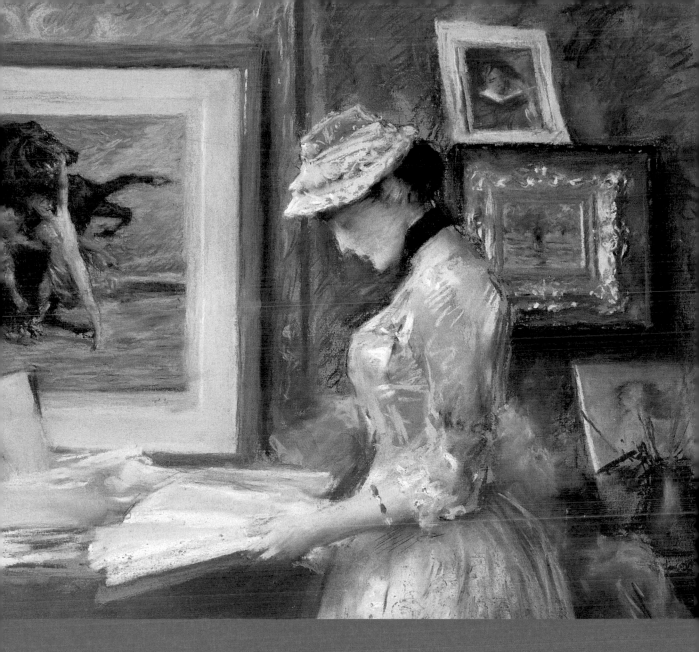

William Merritt Chase

Erica E. Hirshler

MFA PUBLICATIONS · MUSEUM OF FINE ARTS, BOSTON

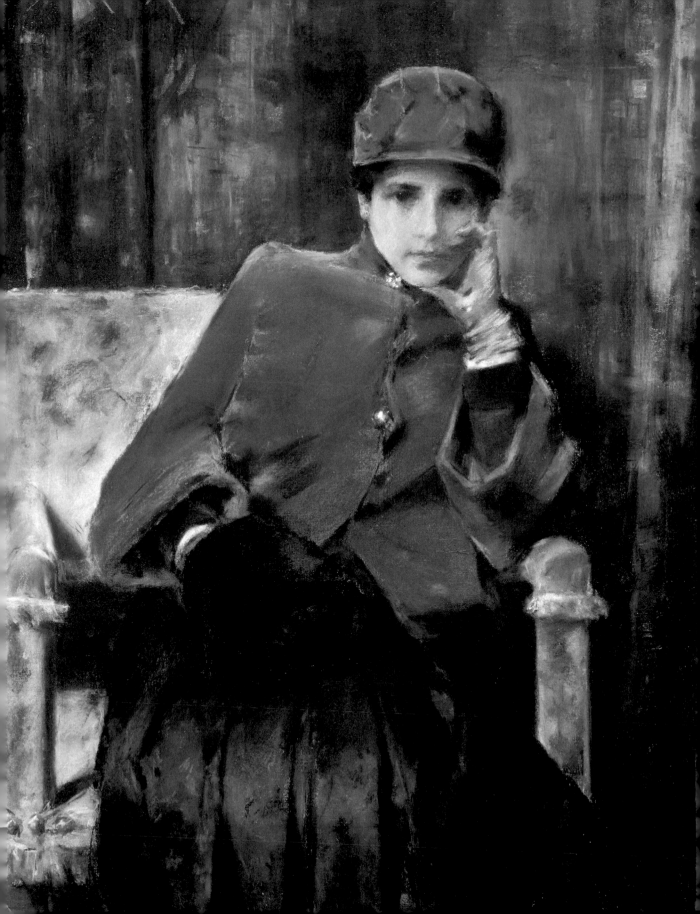

Contents

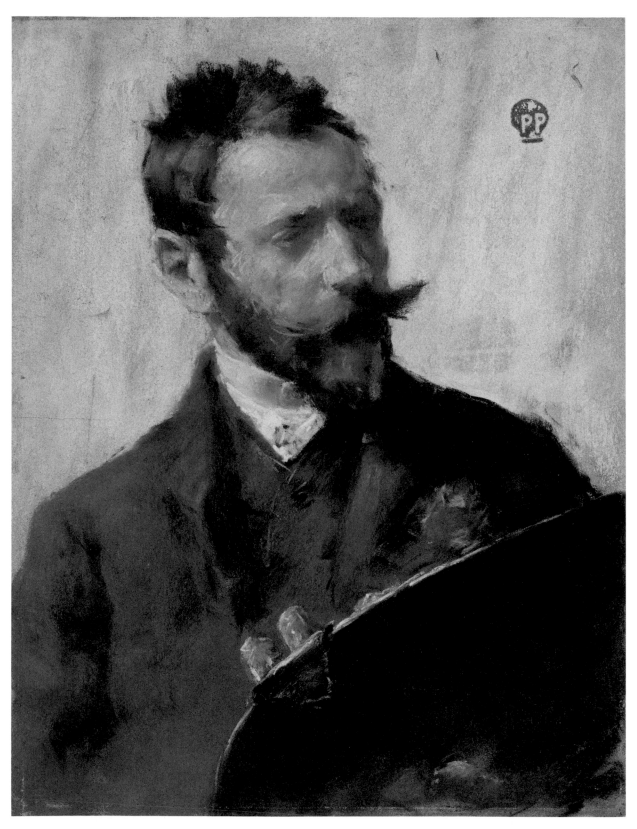

Self-Portrait, about 1884. Pastel on paper, 43.8 x 34.3 cm (17¼ x 13½ in.). Private collection

The Artist's World

William Merritt Chase, painter, teacher, and champion of American art, celebrated beauty in the world and found joy in his craft. He began his career in the 1870s and worked into the 1910s, helping to transform culture in the United States from a commodity available only for purchase in Europe to a vibrant, inventive prospect at home. As one writer would describe his legacy, Chase had "passed through a time when Americans were looked upon solely as people who bought works of art, but could not create them, to the time when American canvases held their own in the galleries and salons abroad," proclaiming that "it was largely through [Chase's] own work, both as painter and teacher, that this change was brought about."[1]

The eldest of six children, Chase was born in Nineveh, Indiana, in 1849, where his father ran a shoe store. After several unsatisfying years as a salesman and a brief stint in the Navy, Chase turned his attention to mastering the art he had always adored. He studied briefly in New York and then, with the support of several St. Louis businessmen, traveled to Europe in 1872 to study at the Munich Academy, a rigorous art school popular with aspiring painters from the American Midwest, a region with strong German cultural roots. There he developed a rich, dark, sculptural painting style and a

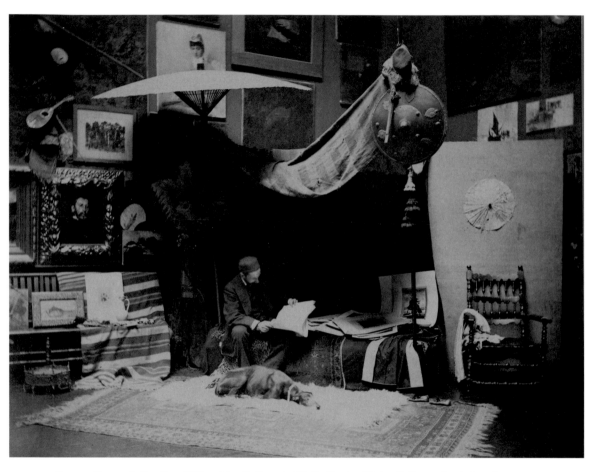

Figure 1. George Collins Cox, *William Merritt Chase in His Studio at 51 West 10th Street*, about 1879–83

lifelong love for the works of the old masters, particularly Rembrandt, Frans Hals, and Diego Velázquez. He began to build his American reputation by sending paintings from Munich to New York City for display, following them in person in 1878 and setting himself up in the Tenth Street Studio Building, at the center of the city's art world.

On Tenth Street, Chase created a studio environment that reflected his eclectic tastes and his belief in the transformational power of art. Modeled

on European precedents, his rooms became a temple to art and a destination for aesthetic pilgrims. There Chase performed the role of a cosmopolitan bohemian gentleman, dedicating his life to art but—happily married to the former Alice Gerson since 1887 and eventually a devoted father of nine—safe from the dissolute reputation often associated with life in the studio.

Chase painted many different kinds of pictures with equal flair: portraits, figural studies, genre scenes, interiors, landscapes, and still lifes. His facility with paint was remarkable, and his canvases—carefully considered and composed—seem effortless in the way they capture the momentary effects of light and reflection, whether made in full sun out of doors or in the shadowy confines of his studio. Chase developed an American version of Impressionism to depict modern subjects, among them sparkling views of New York's public parks and a series of portraits of "new women"—active, accomplished, and engaged individuals whom Chase rendered with the bravura of the old masters. He often employed daringly abstract compositions, devising interlocking patterns of vertical and horizontal lines or dramatic diagonal sweeps that provided a firm geometric foundation for his loose strokes of color. He also experimented with different media and was an innovator in the revival of painting in pastel. Uniting his diverse productions was Chase's belief in his power to discover the art in the world around him.

Chase never sold enough of his work to support his large family and he depended on his income as a teacher. But teaching brought him further pleasure, and he devoted himself to it throughout the year, in the winter at various art schools in New York, Philadelphia, and Hartford, Connecticut, and in the summer at Shinnecock on Long Island, and in Europe. He was particularly popular with women students, who appreciated his serious instruction, his belief in their artistic potential, as well as his dedicated professional support. Perhaps Chase's success as a teacher is marked by the fact that only some of his students followed his stylistic example; others—among

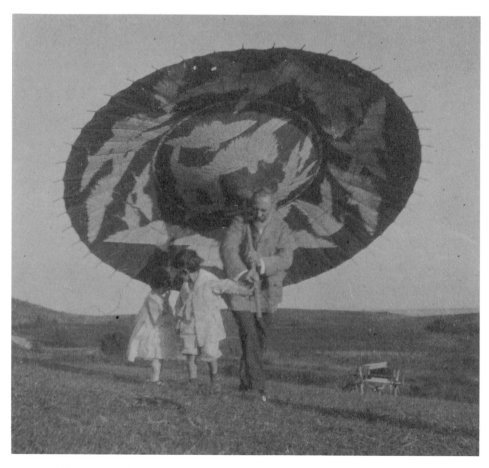

Figure 2. *William Merritt Chase, Mary Content, and Roland, Shinnecock Hills*, about 1905

them Lydia Field Emmet, Rockwell Kent, Marsden Hartley, Edward Hopper, Charles Sheeler, and Georgia O'Keeffe—used what they learned in his classes as a springboard for their own artistic innovations. "I believe I am the father of more art children than any other teacher," he reportedly said.[2]

Despite the acclaim he received during his lifetime, Chase's reputation tumbled after his death, as did the estimation of many of his fellow American Impressionists. He seemed too old-fashioned, too traditional, and too

bound up with the concerns of the Gilded Age to be relevant in a new century that increasingly celebrated either abstraction or social realism in art. Today he is less well known than his contemporaries Mary Cassatt, John Singer Sargent, and James McNeill Whistler, although his position at the heart of the American art world at the turn of the last century—and, most important, his work—are at long last receiving renewed attention from scholars and public alike. Besides, as Georgia O'Keeffe said of her teacher, "There was something fresh and energetic and fierce and exacting about him that made him fun," a spirit that also infused his art.[3]

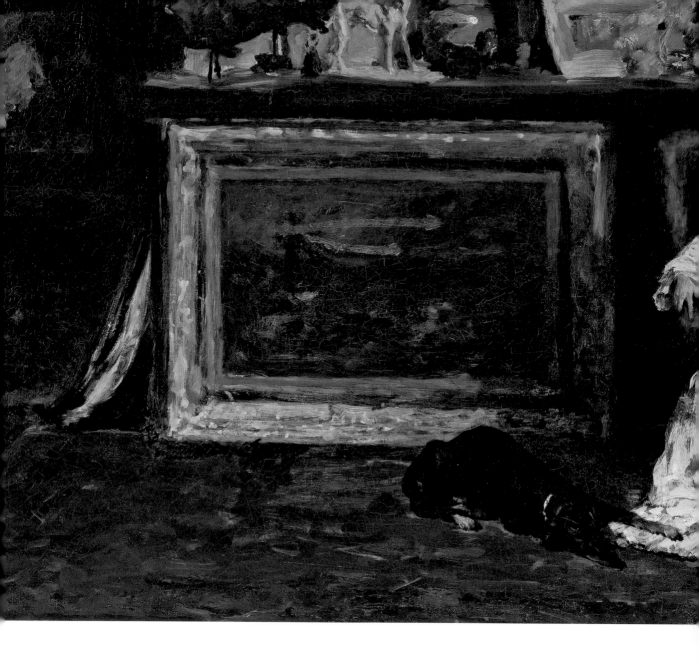

Studio as Theater

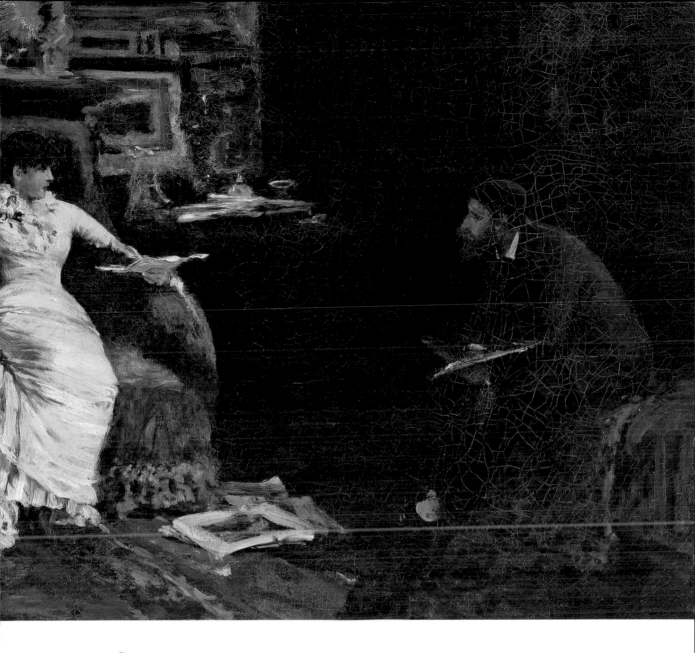

Williiam Merritt Chase turned his studio into a stage. His rooms were both the set and a source for his art. Fond of costume and display, of assembling objects to create harmonious arrangements, Chase directed players on the boards of his studio, which served as the backdrop for his production of painted performances. And entering through his picture frames, like the proscenium of a theater, spectators are invited to suspend their disbelief as they encounter worlds confected from the artist's imagination. "A knock at Mr. Chase's door," wrote one visitor, "was the 'open sesame' to a magical change."[1]

Early in his career, the artist sometimes allowed an object from his studio collection to suggest a fanciful theme, as he did in *"Keying Up"—The Court Jester*. Here a red-garbed fool, bedecked with ribbons and bells, pours himself a dram to key himself up for his performance. He holds a puppet that mimics his own features. The doll was likely Chase's inspiration for the figure of the jester; with the strokes of his brush, he transformed an inanimate object into life.

Invention was not always required—reality sometimes provided enough theater. In 1885, Chase and James McNeill Whistler began to paint portraits of one another in Whistler's London studio. Chase's likeness of his fellow American artist emulated Whistler's spare, self-consciously aesthetic style. When the painting was shown in New York in 1887, one writer reported that "the subject himself protests against it, and it is not surprising. He is hoisted with his own petard. . . . [It] certainly does look like a caricature of Whistler's person, as well as his method; but those who know the eccentric genius will recognize it to be the truth—the harsh truth—neither more nor less." Chase captured Whistler's theatrical persona in the role of an artist, a dramatic character that Whistler himself cultivated. Whistler, though, found the play amusing only when he himself was producer, director, and actor: he called Chase's painting a "monstrous lampoon" and complained about Chase for the rest of his life.[2]

These works, one imaginative and the other perhaps too real, are the sorts of paintings many artists made in the studio. But Chase's relationship to his workspace was exceptional, and the environment he fashioned there became one of his most admired creations. From 1878 until 1895, Chase kept rooms on the first floor of New York's famous Tenth Street Studio Building. Its inhabitants, many of New York's leading painters, took great care to decorate their studios, which served not only as spaces in which to work, but also as sites for exhibition and sale, displaying both art and artist. Some of these rooms expressed seriousness and functionality, with volumes of Shakespeare and a writing desk placed among the paraphernalia of easels and palettes. Others declared authenticity: for example, William Bradford, who specialized in Arctic scenes, filled his studio with snowshoes, Eskimo clothing, and harpoons.

Chase's rooms, which echoed the great studios he had seen and admired in Europe, enhanced his reputation as a well-traveled, dapper, creative practitioner of the arts. Often wearing a fez and accompanied by one of his pet wolfhounds, Chase presented himself against a backdrop of hundreds of objects from around

the world: old master paintings, Japanese parasols, Renaissance furniture, Islamic lamps, fabrics, rustling chimes, great copper pots, and dozens of exotic shoes. "I intend to have the finest studio in New York," he told a friend. With the same eclectic sensibility that unites his works on canvas, Chase created a magical, glamorous, and evocative space.[3]

Chase's studio was as well known as the artist himself. Notices about him often included descriptions of the room, and several illustrated articles enumerated its colorful contents in breathless detail.[4] The studio was a museum, a cabinet of wonders, a place where imagination could run wild. It was also a space where Chase entertained and relaxed. Here the great Spanish dancer Carmencita performed before painters and patrons, here Chase held receptions and dinners, here his clients came to see his work, and his children came

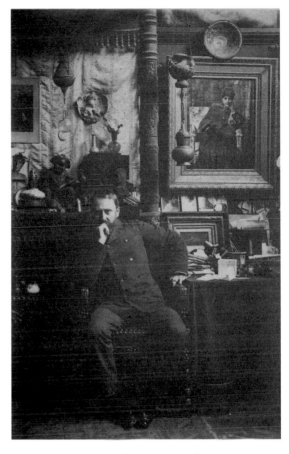

Figure 3. *William Merritt Chase in His Tenth Street Studio*, about 1895

to play. "He collected beautiful things as naturally as one eats, and they were as necessary to him," wrote one visitor. "He lives and banquets on all that arouses the interest of his eye and stimulates his hand to work," said another.[5] The studio not only inspired Chase's art-making, it also became art in more than a dozen interiors he painted in the 1880s.

Still life combines with real life in these studio scenes. Fabrics and furnishings are lovingly depicted with great attention to their texture and sheen, walls are crammed with paintings and porcelains, shelves are laden with bric-a-brac. Actors, most often women, enliven these sets; they paint, read, converse, and assess paintings and prints. Chase's own works often appear: unfinished pictures sit on easels, beguiling spectators with renderings of compositions too sketchy to identify but evoking the artist's creative process. Completed paintings

Figure 4. *A Friendly Call*, 1895

in heavy gold frames sit on the floor, attracting the eye and perhaps also the market. Many of these scenes unfold like a drama, with the lines delivered by their inquisitive titles—"May I Come In?" or "Did You Speak to Me?"—as they invite the viewer to enter the conversation by the way in which the framed pictures that Chase painted mimic his actual frames.

While some painters considered their studios exclusive places for work and kept them separate from home and family, Chase had no boundaries between spheres. This is most evident in his Long Island summer home at Shinnecock. He had a designated room there in which to paint, but the whole ground floor sometimes became his temporary studio—just as his studio served as a living space, where his eldest daughter, Alice (nicknamed Cosy), graceful as a gazelle, could lounge comfortably, surrounded by depictions of her family. In the studio, Chase's stagecraft brought art to life and life to art.

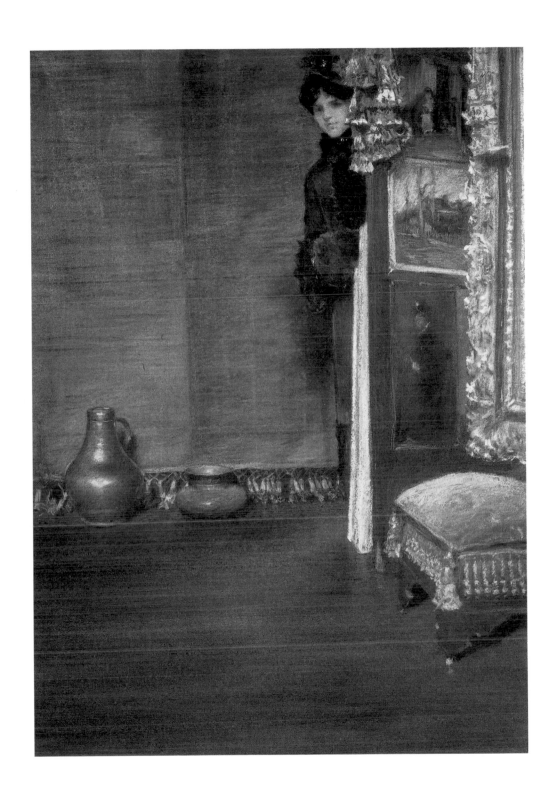

May I Come In?, about 1883
Pastel on paper, 88.9 × 63.5 cm (35 × 25 in.)
Private collection

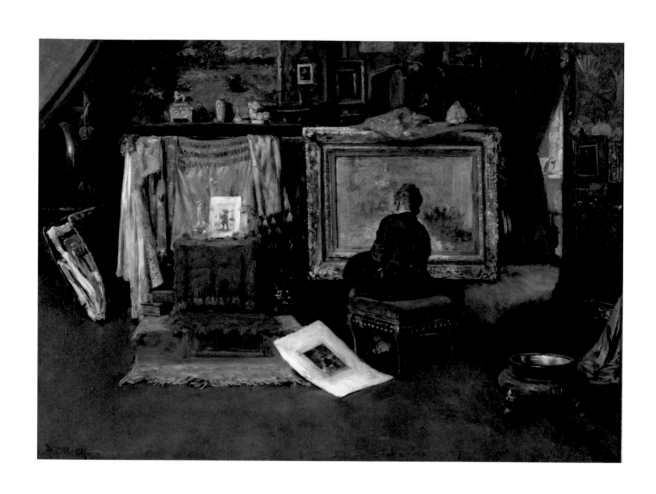

The Inner Studio, Tenth Street, 1882
Oil on canvas, 82.2 × 112.4 cm (32⅜ × 44¼ in.)
The Huntington Library, Art Collections, and Botanical Gardens,
San Marino, California; Gift of the Virginia Steele Scott Foundation, 83.8.7

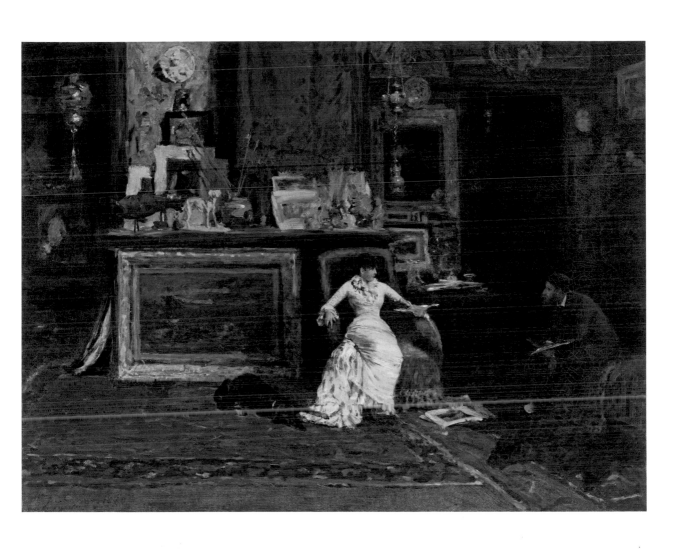

The Tenth Street Studio, 1880
Oil on canvas, 92.1 × 122.6 cm (36¼ × 48¼ in.)
Saint Louis Art Museum; Bequest of Albert Blair, 48:1933

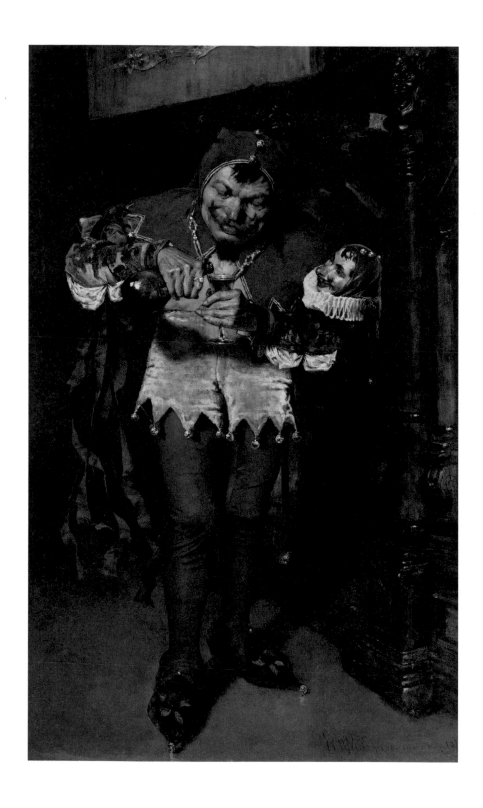

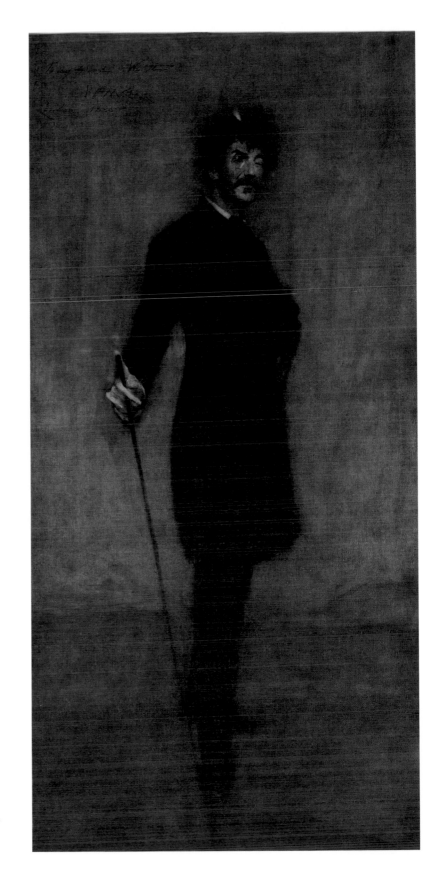

"Keying Up"—The Court Jester, 1875
Oil on canvas, 101 × 63.5 cm (39¾ × 25 in.)
Pennsylvania Academy of the Fine Arts;
Gift of the Chapellier Galleries, 1969.37

James McNeill Whistler, 1885
Oil on canvas, 188.3 × 92.1 cm (74⅛ × 36¼ in.)
The Metropolitan Museum of Art, Bequest of
William H. Walker, 1918, 18.22.2

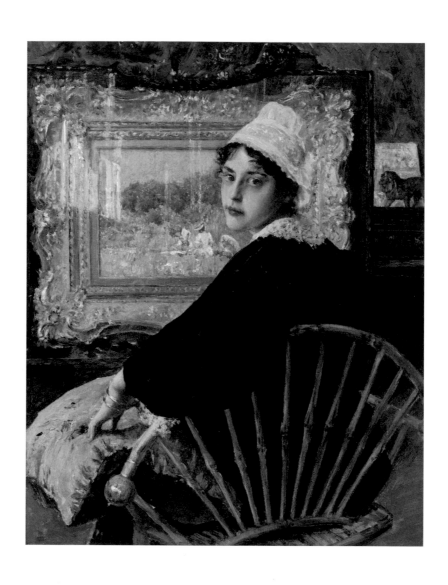

An Artist's Wife, 1892
Oil on canvas, 50.8 × 40.6 cm (20 × 16 in.)
Fayez Sarofim Collection

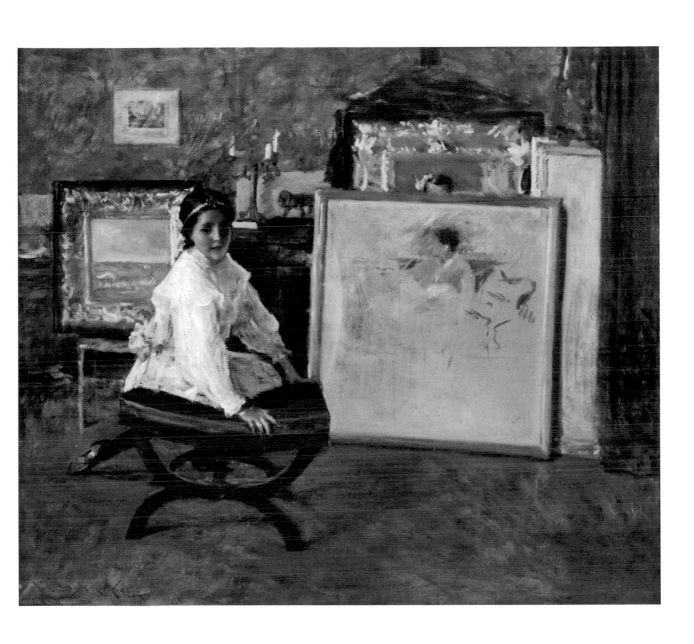

Did You Speak to Me?, about 1897
Oil on canvas, 96.5 × 109.2 cm (38 × 43 in.)
Butler Institute of American Art, Youngstown, Ohio;
Museum Purchase 1921, 921-O-102

Modern Women

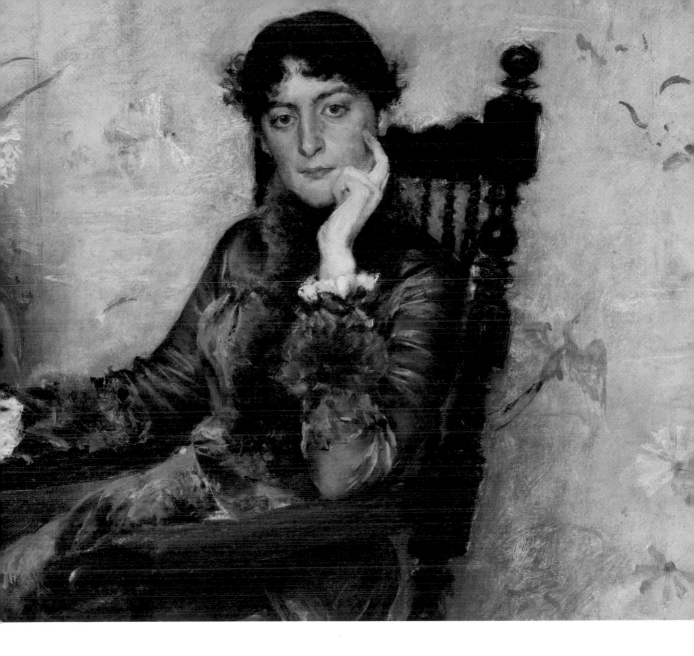

Chase lived happily in a world of women. A loving husband to his wife, devoted father of six daughters, and inspiring teacher of numerous female art students, Chase also made his name by picturing women. He captured them in a variety of roles, both active and meditative, in public and at home, and in professional and domestic guises. His paintings reveal some of the opportunities and challenges women faced during the late nineteenth century, when ideas about women's proper place were undergoing rapid change.

In the United States, these societal shifts were in part the lingering result of the Civil War, which had killed or disabled enormous numbers of men. Women

had to take the place of the missing. Some became breadwinners for their families; others, whose organizational talents had been made apparent through war work (abolition, nursing, procurement, charitable services), kept active in new causes (suffrage, settlement houses, education reform, preservation). As one writer put it, "the eventful years from 1861 to 1867 incited the activity of women to a new phase of development throughout the land. . . . After peace was restored [the] most observant and thoughtful women . . . felt a desire to keep all their forces united by some means, and to continue such educational and social relations."[1] Numerous women's colleges were founded during this period, and women began to enter the professions of medicine, law, and science in addition to occupations traditionally considered more feminine. The female sphere, once expanded, would not be diminished.

Chase's earliest success came with a likeness of a woman on the move. The subject of *Ready for the Ride* pulls on a glove and holds a riding crop; she wears a dark, severely tailored habit in a style known as *en amazone*, named for the brave, independent warrior horsewomen of Greek mythology. She glances back over her shoulder, about to embark on an outdoor adventure. Somehow this image of a determined woman, modeled in a Munich studio and deliberately referring to Rembrandt with the Dutch-style hat and collar, also calls to mind the American sculptor William Wetmore Story's description of Harriet Hosmer, one of his artist compatriots in Italy: according to him, she would "have the Romans know that a Yankee girl can do anything she pleases, walk alone, ride her horse alone, and laugh at their rules."[2]

Chase continued to celebrate modern women throughout his career, showing them in a variety of activities, both public and private. He invested even his most traditional images with a sense of agency and action. In *"I Think I Am Ready Now,"* a woman stands before a mirror tidying her hair. She poses as a demure modern-day Venus, the mirror an age-old token of beauty and vanity. Chase delights in the gestural strokes of paint he used to describe the supple folds of her pink gown but at the same time cedes control of the scene to her with his narrative title. She, not he, is the one who decides when she will be ready for action.

Before the middle of the nineteenth century, women of a certain class and level of propriety—the likely buyers of Chase's work—would not have gone out in public alone. But in the decades that followed the Civil War, urban life changed and women with it. Department stores, public musical and theatrical

performances (particularly matinees), lectures and recitals, restaurants, museums, and civic parks all offered new spaces in which women were welcomed as consumers and connoisseurs.[3] In the mid-1880s, Chase made a series of paintings of women in public parks and at seaside retreats in Manhattan and Brooklyn. In *A City Park*, a view of Tompkins Park in Brooklyn, a well-dressed young woman in a pink gown, black jacket, and stylish hat sits by herself on a park bench. She is alert, turning to face the viewer, although Chase has blurred her features, perhaps in acknowledgment of the recommendations in contemporary etiquette manuals that advised women in public places never to catch the eye of a stranger. This park, groomed and cultivated, is a domesticated oasis; populated almost exclusively by women and children, its broad promenade ends in a view of the apartments on Marcy Avenue (a respectable residential neighborhood and Chase's own).[4] The setting, like Chase's model herself, is modern, urban, and safe.

A woman also sits alone in *The End of the Season*. She turns her back to the observer as she leans forward on a table to watch the distant waves and the activities around a fishing boat on an unidentified beach. Empty tables and tipped-up chairs cartwheel down to the strand; this contemplative woman is clearly the last guest, her hours filled with her own thoughts. *Meditation*, a pastel portrait Chase made of his wife, presents an analogous situation. Alice wears gloves, a hat, and a heavy jacket, and holds a fur muff in her lap. Ready to go out, she has paused, losing herself in a moment of contemplation, chin in hand. Unlike her seaside associate, Alice Chase faces the viewer, but both women are alone in their reflections. These women are not only engaged with the physical world outside the home, but also occupied with the world of the mind. As one newspaper advertiser announced in 1885, echoing the declarations of innumerable contemporary essays, "the women of today are thinking, thinking, thinking, as women did not think in the old times."[5]

Several of the women that Chase showed in quiet attitudes were vibrant participants in the art world, among them Dora Wheeler and Lydia Field Emmet. Chase asked both women to pose; they were former students, artists he admired, and women who understood that a portrait could be much more than a simple likeness. Chase painted Wheeler in her own studio, emphasizing her status as a professional colleague. The Asian-inspired textile backdrop and blue ceramic pot refer to her work as a designer, although Wheeler was already seeking to

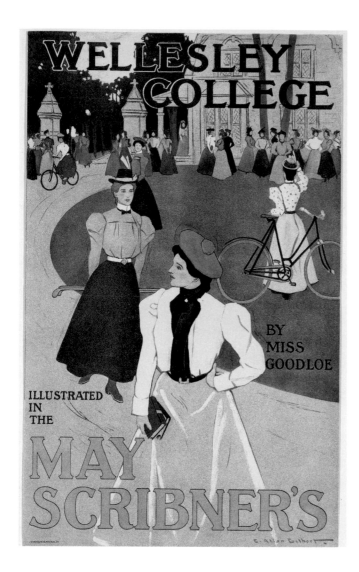

Figure 5. Charles Allan Gilbert, *Wellesley College Illustrated in the May Scribner's*, 1898

establish herself as a painter, having just returned from further instruction in Paris. Chase made his portrait of Lydia Field Emmet about ten years later, showing her radiating all the confidence a successful artist required. She stands with one arm akimbo, looking back over her shoulder in a pose particularly associated in popular posters and illustrations with the "new woman" of the 1890s—assertive, active, and independent. Chase had used a similarly self-assured pose for another of his students who became a successful painter, Mariette Cotton, in a portrait titled *Lady in Black*. He not only depicted these talented artists as distinct and modern individuals; he also used their portraits to proclaim his

own progressive position, exhibiting them repeatedly and earning prizes for them, symbiotically promoting both himself and the new attitudes and roles for women.[6]

New roles did not preclude traditional ones, despite rhetoric in the popular press that implied otherwise, augmented with images of henpecked house-husbands and women in men's attire. Most progressive women anxiously sought to reassure the public that their quest for equal opportunity did not threaten home and hearth. Some of Chase's most beautiful works show women in maternal roles. *For the Little One* is a portrait of Alice Chase sewing a long white garment for one of her children, perhaps her fifth daughter, Helen, born a year before the painting was made. Set in the large hall of the Chases' summer home at Shinnecock, the image, though modern in its style, presents a comforting picture of conventional family life. One critic described it as a "charming little domestic idyll, a poem without words."[7] The article appeared

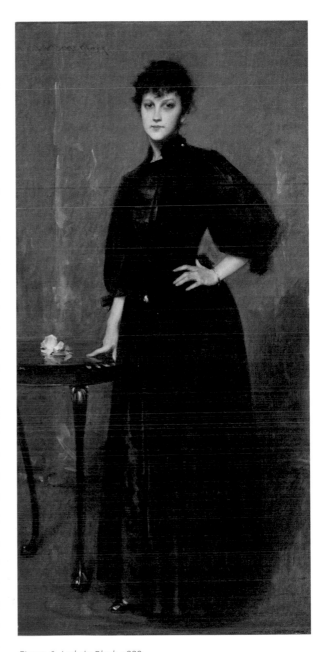

Figure 6. *Lady in Black*, 1888

when *For the Little One* was displayed in a prominent exhibition for the sixth time, a reminder that in Chase's art, the borders between private life and public display were porous. His paintings, like the women of his day, were not constrained to a single sphere.

Ready for the Ride, 1877
Oil on canvas, 137.2 × 86.4 cm (54 × 34 in.)
Museum of Fine Arts, Boston; Henry H. and
Zoe Oliver Sherman Fund, 2014.1466

Lydia Field Emmet, 1892
Oil on canvas, 182.9 × 91.8 cm (72 × 36⅛ in.)
Brooklyn Museum, New York;
Gift of the Artist, 15.316

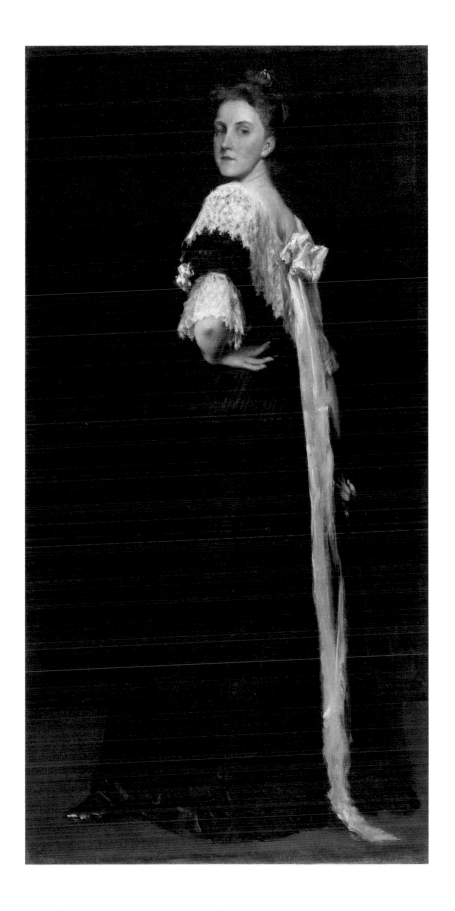

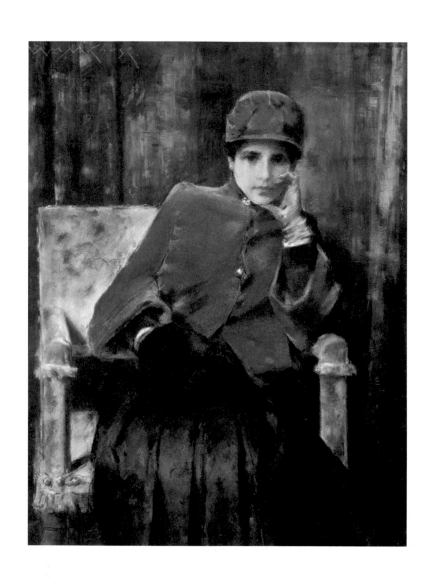

Meditation, 1886
Pastel on canvas, 65.4 × 48.9 cm (25¾ × 19¼ in.)
Willard and Elizabeth Clark

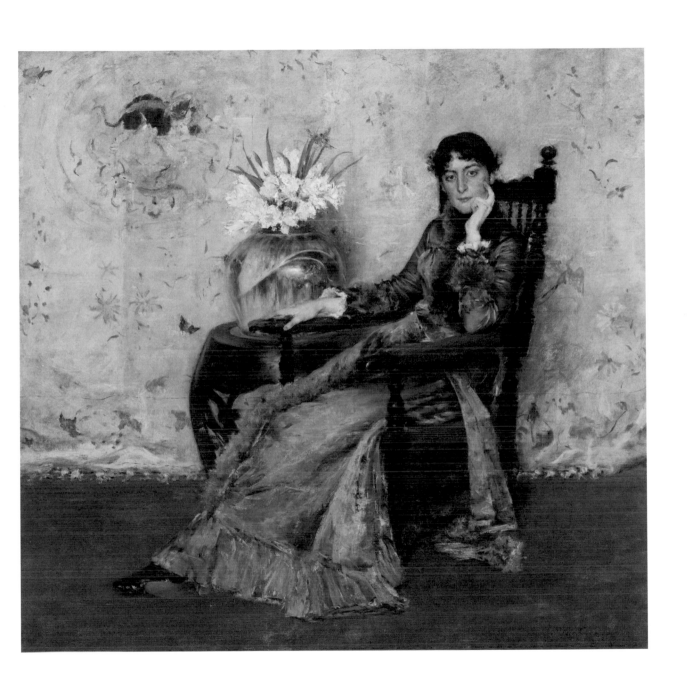

Dora Wheeler, 1882–83
Oil on canvas, 159 × 165.5 cm (62⅝ × 65⅛ in.)
The Cleveland Museum of Art; Gift of Mrs. Boudinot Keith
in memory of Mr. and Mrs. J. H. Wade, 1921.1239

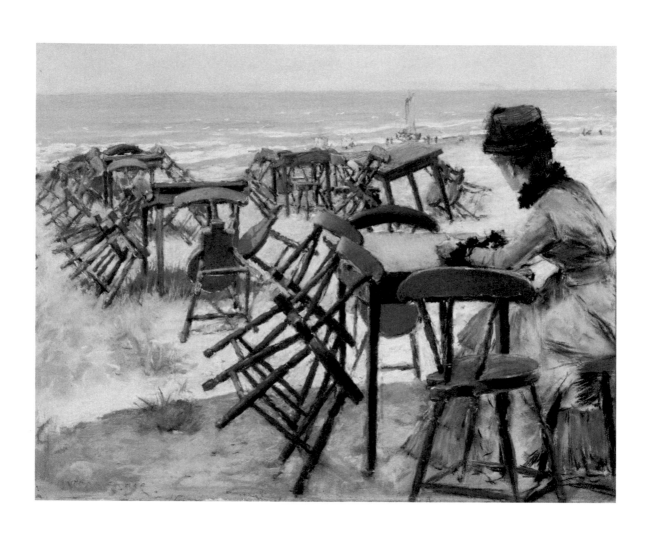

The End of the Season, about 1884–85
Pastel on paper, 35.6 × 45.7 cm (14 × 18 in.)
Mount Holyoke College Art Museum, South Hadley, Massachusetts;
Gift of Mrs. Dickie Bogle (Jeanette C. Dickie, Class of 1932), MH 1976.9

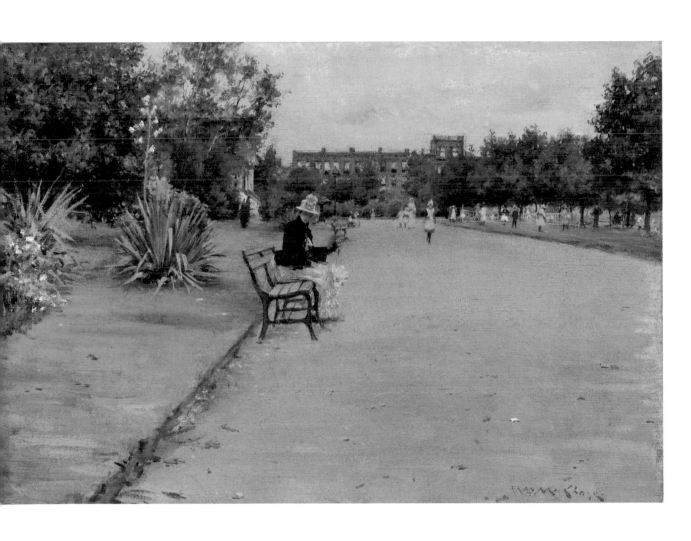

A City Park, about 1887
Oil on canvas, 34.6 × 49.9 cm (13⅝ × 19⅝ in.)
The Art Institute of Chicago; Bequest of Dr. John J. Ireland, 1968.88

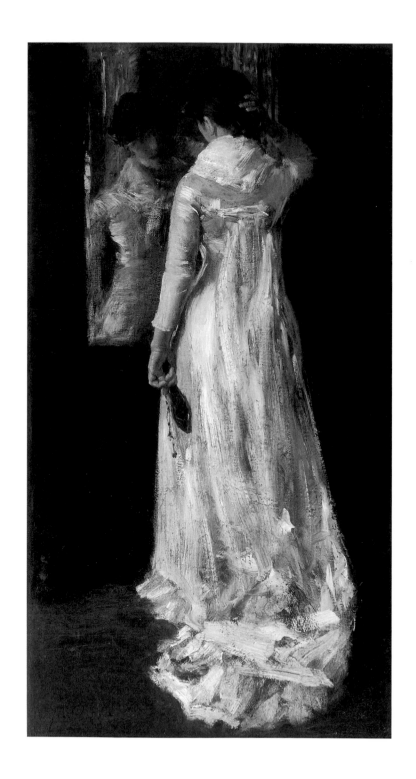

"I Think I Am Ready Now," about 1883
Oil on canvas, 82.6 × 44.5 cm (32½ × 17½ in.)
Private collection

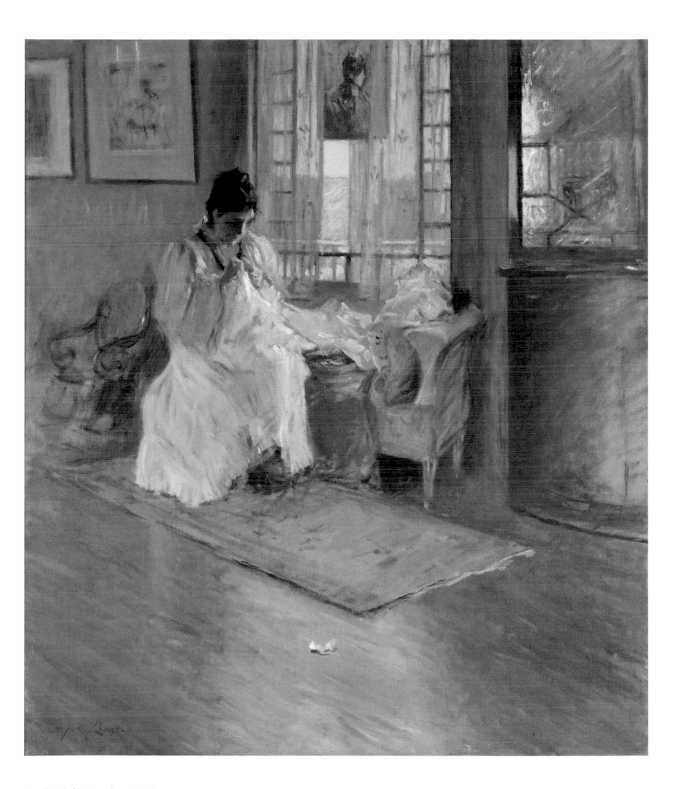

For the Little One, about 1896
Oil on canvas, 101.6 × 89.5 cm (40 × 35¼ in.)
The Metropolitan Museum of Art; Amelia B. Lazarus Fund, by exchange, 1917, 13.90

Japonisme

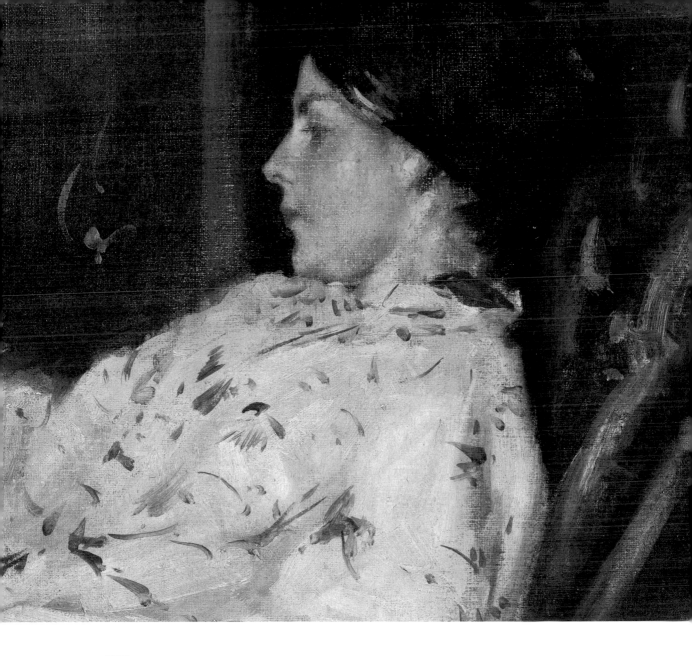

Japonisme refers to the late nineteenth-century fad for all things Japanese in European and American culture, both in the highest artistic circles and in popular taste. Objects from Japan had been admired in the West for centuries, but beginning in the 1860s, a new political regime in Japan that stressed modernization, industry, and trade with the West found mutual self-interest with an imperialist attitude in Europe and the United States. While often professing their own cultural and political superiority, Westerners were also intrigued and inspired by the unfamiliar. Japanese prints, ceramics, textiles, furniture, and decorative arts flooded the Western market, influencing

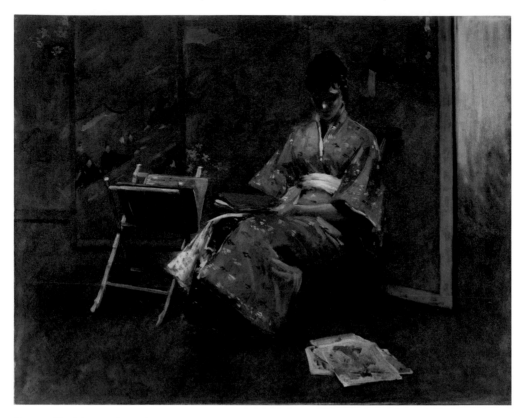

Figure 7. *The Kimono*, about 1895

everything from architecture to Zola, the French writer whose fictional Parisian prostitute Nana kept a Japanese screen in her bedroom. Artists, captivated by this plethora of goods, incorporated Japanese effects in a variety of ways. Some studied the sophisticated design principles of Japanese pictorial art and adapted them in their own work, experimenting with condensed perspective, asymmetrical composition, and cropping. Others simply played dress-up, wrapping their models in kimonos or posing them with fans and lacquered furnishings. Chase, who collected beautiful things from around the world, did both.

The first large display of Japanese art in the United States was held in Philadelphia as part of the Centennial Exhibition in 1876, and it introduced Asian art, already known in many aesthetic circles, to a broad public audience. At that moment, Chase was in Germany, where he could have seen "products of the most civilized Asiatic nations" at the Bavarian State Ethnographic Museum.[1] Chase eagerly sought out Japanese objects on his return to the United States. He soon

met Shugio Hiromichi, the Oxford-educated son of a samurai family, who went to New York about 1880 to promote Japanese trade, establishing a shop at Eighteenth Street and Broadway, close to Chase's Tenth Street studio. Both men were members of the Tile Club, a self-consciously bohemian artists' association, complete with nicknames—Chase was "Briareus," a many-handed figure in Greek myth, and Shugio was "Varnish." Members of the club sketched, painted, and traveled together, and no doubt also had the chance to see Shugio's own impressive collection of Japanese books and prints, either privately or when they were displayed at the Grolier Club.[2] And of course many American artists were

influenced by their compatriot James McNeill Whistler, whose paintings of women in Japanese dress surrounded by Asian objects had first been exhibited in the 1860s, and whose particular adaptation of Japanese aesthetics in both landscapes and portraiture had affected a generation. Chase admired Whistler enormously and considered him "one of the greatest masters of this time."[3]

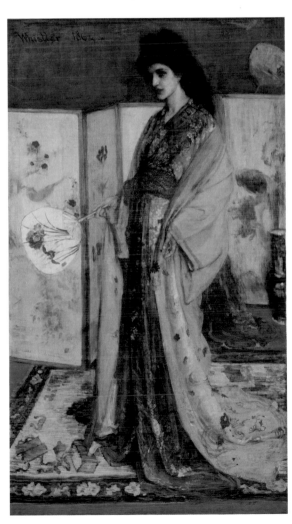

Figure 8. James McNeill Whistler, *The Princess from the Land of Porcelain*, 1863–65

Among the myriad objects in Chase's studio were a large number from Japan: a "glass" teapot; knives; armor and shields; bronze kettles, braziers, and pots he had acquired after the Centennial, among them a decanter "iridescent in its polished surface, fine as only the Japanese can make an alloy, with handle and faucet of the most grotesque dragons"; and a sixteenth-century screen "representing court life of the

tenth."[4] He also owned Japanese umbrellas, visible both as decoration in studio interiors and in use as parasols on the beach (see pp. 8, 10, 55), as well as kimonos, fans, prints, books, and Japanese costume dolls. These items were all easily obtained in New York City, either at his friend Shugio's shop or one of many others in a city that was the retail center for Japanese goods in the United States.[5]

Chase's interest in Japan also became personal. In 1888, he named his second daughter Koto, after one of his favorite students, the Japanese painter Koto House, expressing his admiration both for her and for her native land.[6] His earliest kimono picture, also made in 1888, depicts his eldest daughter, Alice, known as Cosy. The child wears a blue-gray garment, with a tightly wrapped red obi holding her in place as if it were a swaddling band. Although the pastel was first exhibited with the title *My Baby*, some critics willfully ignored the identification of its subject, seeing instead "a little Japanese child in Japanese dress, whose oblong lids, brown eyes and Oriental cut of hair prove it a true product of Nippon, whatever doubts the catalogue may cast upon its nationality."[7] Today such language seems regrettably inappropriate, with its objectification of Asian identity and potential equation of a child with merchandise, but Chase is unlikely to have perceived it that way. He capitalized on popular taste, to be sure, but he also intended to pay homage to art he deeply admired. Cosy came to share his enthusiasm, and some years later, her father captured her carefully examining a Japanese book on the floor of his Shinnecock studio.

Two figurative compositions from this period, *The Japanese Print* and *A Comfortable Corner*, show Chase's interest in Japanese art in the context of his penchant for accumulating an eclectic array of beautiful things, while also revealing at least some understanding of Asian compositional devices. Both depict dark-haired women dressed in kimonos; they resemble his wife, Alice, but they may instead be models or students willing to pose. That they are not Japanese is evident: in *The Japanese Print*, the woman wears her kimono as if it were a dressing gown, loosely wrapped without an obi. She reclines in a Morris-style armchair and holds an early nineteenth-century Japanese woodblock print. Only the rhythmic vertical lines behind her (a frame, a doorway, a curtain), which serve to flatten the space, betray knowledge of the underlying structural principles of Japanese art. The setting of *A Comfortable Corner* is even more diverse, for it includes a Japanese screen and a large bronze vessel, along with Chinese textiles and a Persian carpet. Here the model, wearing a blue kimono and holding a fan,

rests on a red Western-style divan and confronts the viewer directly. Her legs are demurely crossed at the ankle, but the robe allows a glimpse of her polished leather shoes, black silk stockings, and white ruffled petticoat, reinforcing common sensual associations of women, silk textiles, and Asia. Once again, Chase uses the edges and borders of the rug, sofa, and screen to provide an underlying geometrical structure to his composition, much as Whistler had done in many of his portrait "arrangements" and in his own japonesque fantasies—although the solidity of Chase's forms and the animation of his brushwork prevent this composition from looking anything but Western.

Several of Chase's portrayals of women in kimonos are Japanese in costume only—a dark-haired, blue-eyed beauty who wears a gray garment gazes thoughtfully at the viewer, while another, dressed in red, turns away entirely in an exquisite tour de force of pastel. In a carefully balanced still-life composition, Chase arranged two Japanese dolls, two fans, a lustrous ceramic jar, and a screen. Whereas all of these include Asian objects, none mimics Japanese design principles; these are costume pictures in keeping with images Chase made of women wearing Spanish mantillas or Dutch caps, or his still lifes of Chardin-esque copper pots or of fishes reminiscent of paintings from seventeenth-century Holland. As the novelist Henry James wrote to a friend in the 1860s, praising the cultural appropriation that he (and many contemporaries) considered to be one of the most positive aspects of the diversity of the United States, Americans "can deal freely with forms of civilization not our own, can pick and choose and assimilate and in short (aesthetically, etc) claim our property wherever we find it."[8] Chase found beauty in all manner of things from around the world and, like an actor, prized his ability to embrace new identities at will.

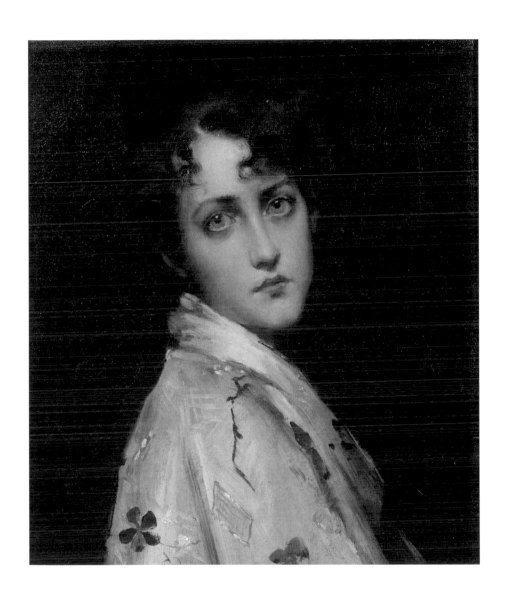

Young Lady Wearing a Gray Kimono, about 1890
Oil on canvas, 47 × 40.6 cm (18½ × 16 in.)
Private collection

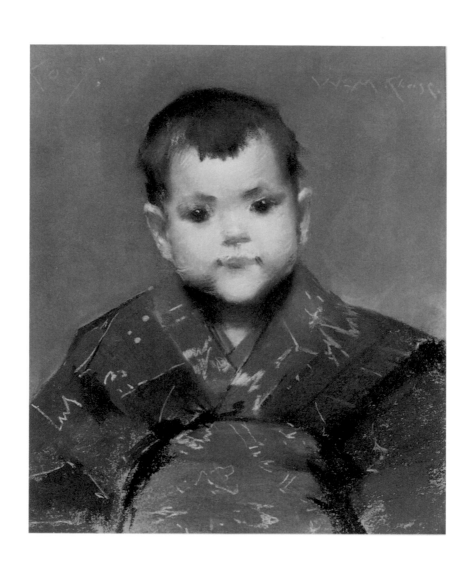

My Baby Cosy, 1888
Pastel on paperboard, 35.6 × 30.5 cm (14 × 12 in.)
Private collection

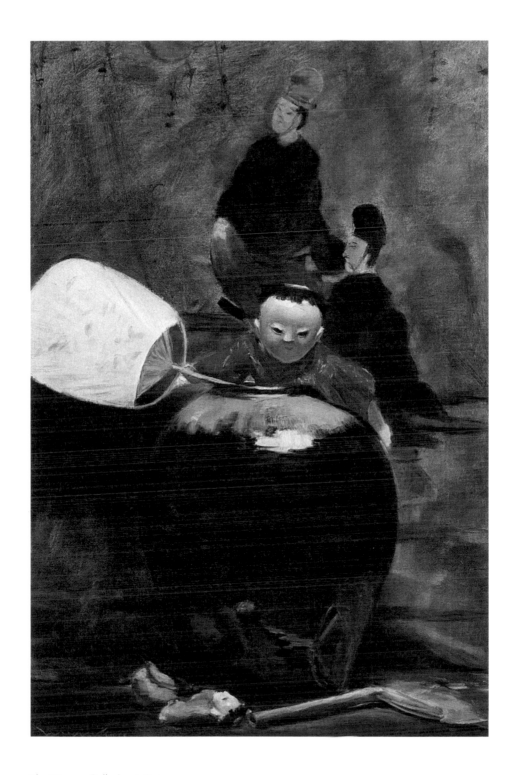

The Japanese Doll, about 1890
Oil on canvas, 76.2 × 50.8 cm (30 × 20 in.)
Private collection

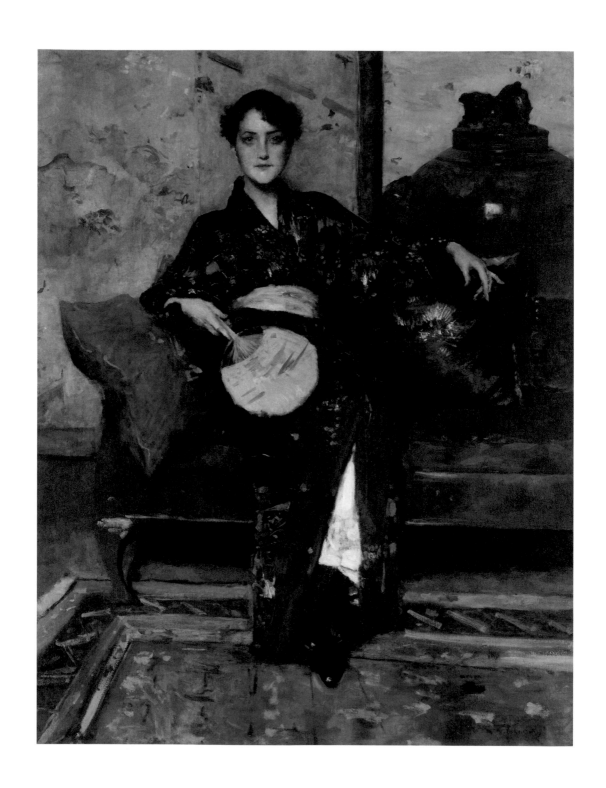

A Comfortable Corner, about 1888
Oil on canvas, 144.8 × 113 cm (57 × 44½ in.)
Parrish Art Museum, Water Mill, NY; Littlejohn Collection, 1961.5.21

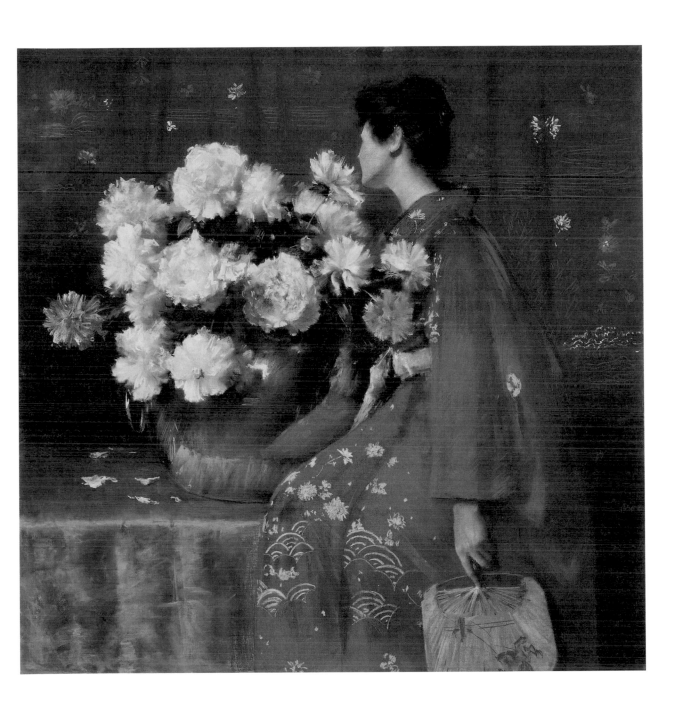

Spring Flowers (Peonies), about 1889
Pastel on paper, 121.9 × 121.9 cm (48 × 48 in.)
Terra Foundation for American Art, Daniel J. Terra Collection, 1999.32

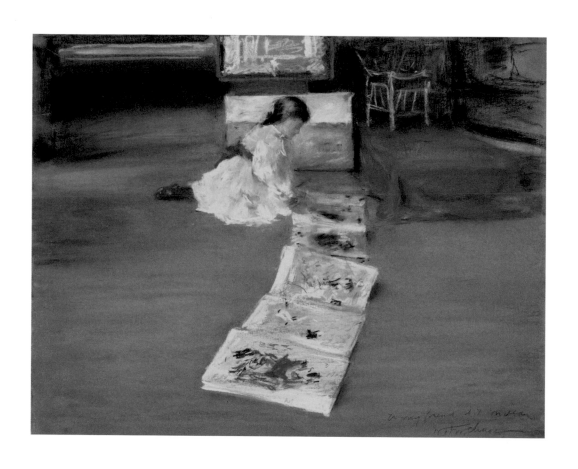

Shinnecock: Studio Interior, 1892
Pastel on paper mounted on canvas, 40.6 × 50.8 cm (16 × 20 in.)
Terra Foundation for American Art, Daniel J. Terra Collection, 1992.5

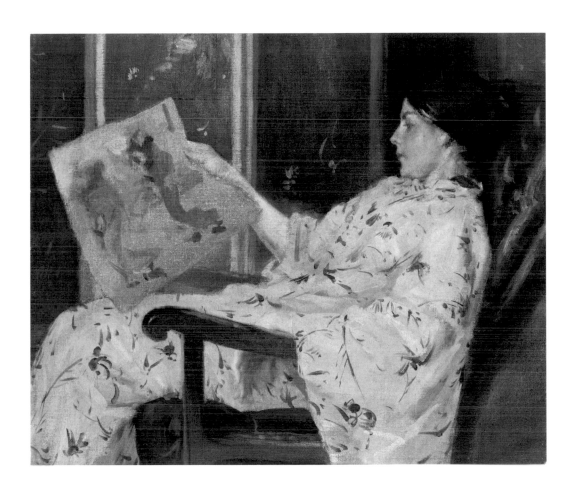

The Japanese Print, about 1888
Oil on canvas, 50.8 × 61 cm (20 × 24 in.)
Neue Pinakothek, Bayerische Staatsgemäldesammlungen, Munich

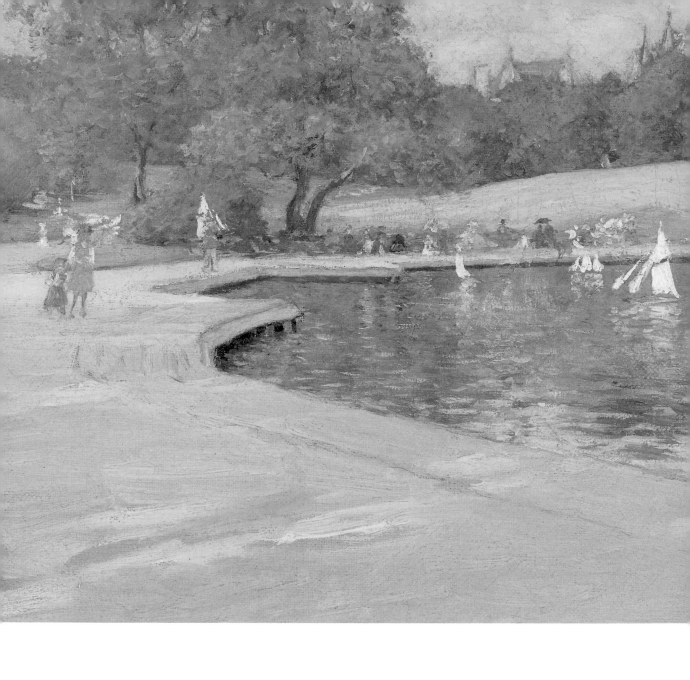

Child's Play

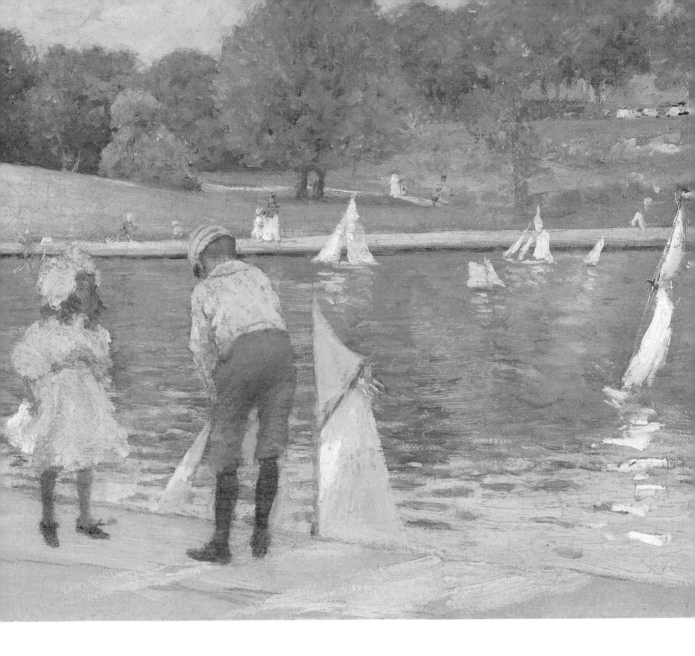

mong Chase's earliest paintings are images of children at play, a theme he embraced throughout his career. As leisure time expanded in American society and childhood was increasingly considered a separate phase of life, play was given serious attention. It was celebrated as a positive activity that (in addition to providing enjoyment) channeled children's surplus energy and taught valuable lessons for adulthood. But "true child's play," according to one educator, was "a sacred mystery."[1]

There was time for play even among the many children who worked. In Munich in the 1870s, Chase painted several pictures of local apprentices,

working boys he posed as if in moments of freedom: whistling, smoking, eating apples, or persuading others to join in mischief. In *The Leader* (originally titled *Impudence*), a brazen youngster with filthy hands and a bandaged finger has clearly been the instigator of some unsanctioned amusement or prank. With his thumbs hooked in his apron, chin raised, and a satisfied smirk on his face, he assumes a posture of adult assurance and authority. Chase captured him at a critical moment, between youth and maturity, humorous stunt and serious act. Critics admired the liveliness of these paintings—the energy of the boys themselves as well as its expression in Chase's active brushwork. Both artist and subject were apprentices at play, showing off their confidence and vigor.

Although Chase began by depicting working-class children, most of his images of play record the games and pastimes of youngsters whose families could afford their leisure. Children from wealthier families were often guided toward structured play: sports, games, and other activities that taught lessons in comradeship and responsibility. Among Chase's most evocative paintings is *Hide and Seek*, which shows two well-dressed girls in a dark, sparsely furnished room. Neither the girls' identities nor the room's location can be securely established, but the game is familiar to everyone. Critics described Chase's painting as a winsome view of children, a charming demonstration both of his craftsmanship and of the mischievous nature of play, with one girl clearly lost and the other found. But Chase also created a complex game for himself, a play on the nature of representation. He devised a spare layout of horizontal and vertical lines—the edge of the frame, the seat of the chair, and the baseboard vie with the fall of the gold curtain at left, the chair legs, and the shaft of light from the window. These two-dimensional patterns are set against the three-dimensional illusion of a view into a room. Drawing upon his knowledge of Asian design, of James McNeill Whistler's carefully arranged, stark interiors, of photography's inherent compression of space, and of the mysterious world of childhood explored by such colleagues as John Singer Sargent, Chase created an aesthetic picture puzzle. Is this a flat abstract arrangement? Or is it an accurate depiction of a real space?

Chase's own children were his favorite models for pictures of children at play. *I'm Going to See Grandma*, a double portrait of Chase's wife and daughter, shows the two-year-old Cosy wistfully turning away from play as her mother engineers her arm into her coat. She has just dropped the leash of her wheeled

pull-toy, a charmingly fluffy sheep, while a Japanese costume doll lies abandoned on the seat at right. *At Play* shows Koto Chase holding the ribboned sash of her younger sister Dorothy's dress like reins as they prepare to play horse and driver, a boisterous pastime particularly attractive for the dominant older child. *The Ring Toss* is set in Chase's studio, once again demonstrating the permeable border between work and play, business and family. Here an older Cosy takes the lead in another indoor game, caught as she gets ready to throw a rope ring around a standing pin, while her sisters Koto and Dorothy wait their turn.

Chase's children were not restricted to inside activities. In keeping with the times, girls as well as boys were encouraged to enjoy the outdoors. The 1887 *American Girls Handy Book*, for example, recommended that as soon as warm weather arrived, girls should form a walking club to promote "health, good spirits, and sociability," as well as "a closer acquaintance with Nature."[2] The hobbies and handicrafts outlined for girls tended toward the decorative and domestic—gathering flowers for enhancing the home, crafting birch bark baskets, making prints from leaves—but the book also proposed lawn tennis and other active sports. Educators recommended that all children play freely outdoors, to foster their mental and spiritual development as well as their physical growth. "Give the children room to be spontaneous and independent," one popular family journal advised about trips to country retreats, noting that both boys and girls should be urged to run, dig, collect, to get into

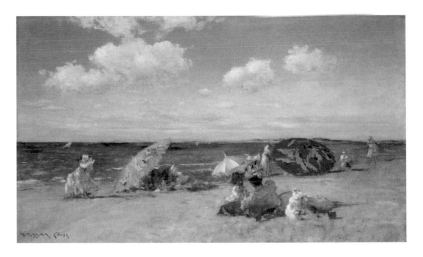

Figure 9. *At the Seaside*, about 1892

things and explore. "After a full course of savagery," another magazine asserted about the benefits of unstructured play, children "will be well prepared to withstand the ravages of civilization."[3]

At Shinnecock, where Chase and his family spent their summers after 1891, the rural setting allowed for more casual pursuits: the girls pick flowers, dig in

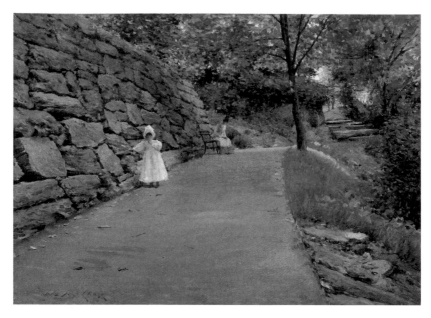

Figure 10. *In the Park (A By-Path)*, about 1889

the sand, collect shells, or listen to stories. In *The Big Bayberry Bush*, Cosy, Koto, and Dorothy are arrayed in the wild grass and scrub surrounding their house, which appears in the distance behind them. They are free from rules and supervision, but safely within sight of home. All three girls wear white dresses, but their sashes, ribbons, and stockings add notes of blue, yellow, and red to the composition; their father plays with these primary colors just as his daughters play in the sandy dunes.[4]

For those families remaining in the city, Central Park offered a simulated countryside, with its carefully sculpted landscape of rocks and trails, lakes and pastures. It drew citizens from across the economic spectrum, but some attractions appealed principally to children of means. In *The Lake for Miniature Yachts*, Chase depicted the park's Conservatory Water, an artificial pond with a broad, bench-lined embankment that hosted a fleet of toy sailboats. There, alongside the miniature yachts "with their pennants flying" could be found "their owners shouting with enthusiasm . . . full of young joyous life." Those youngsters would become the nation's future leaders, "the 'real defenders of the Cup,'" captains of prizewinning vessels and captains of industry, whose early games provided lessons for adult victory.[5] Through play, children mastered skills that prepared them for life.

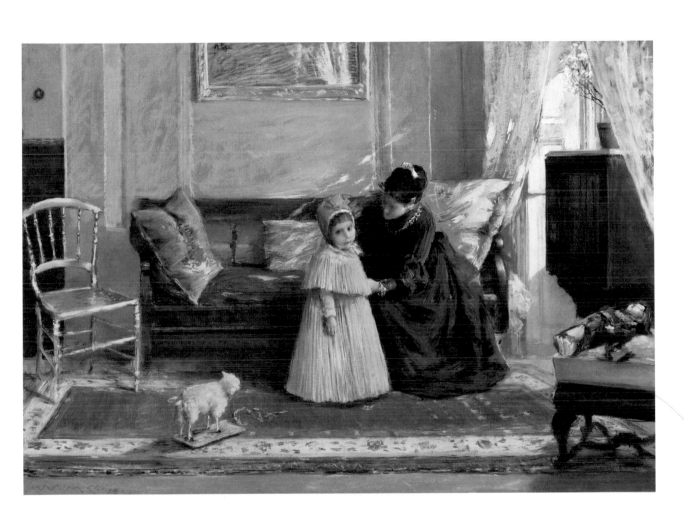

Mrs. Chase and Child (I'm Going to See Grandma), about 1889
Pastel on paper, 73.7 × 104.1 cm (29 × 41 in.)
San Antonio Museum of Art, Texas; Gift of Mrs. Frederic G. Oppenheimer, 50.6

The Leader, about 1875
Oil on canvas, 66.7 × 40.3 cm (26¼ × 15⅞ in.)
Addison Gallery of American Art, Phillips Academy, Andover, Massachusetts;
Gift of anonymous donor, 1931.1

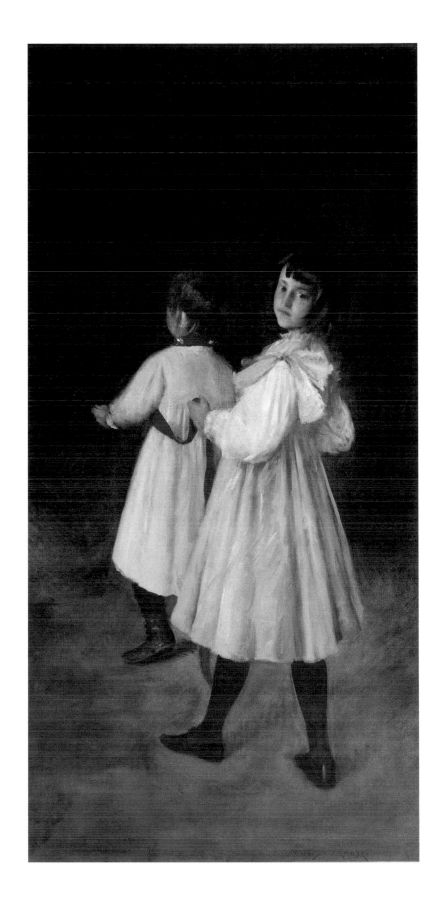

At Play, about 1895
Oil on canvas, 182.9 × 91.4 cm (72 × 36 in.)
Private collection

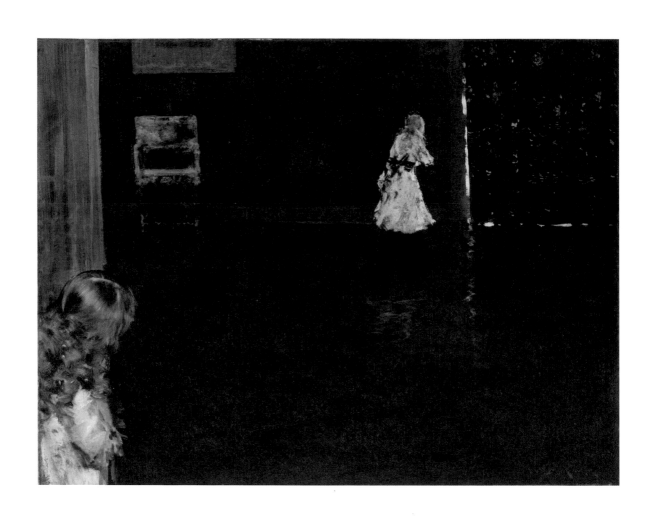

Hide and Seek, 1888
Oil on canvas, 70.2 × 91.1 cm (27⅝ × 35⅞ in.)
The Phillips Collection, Washington, DC; Acquired 1923

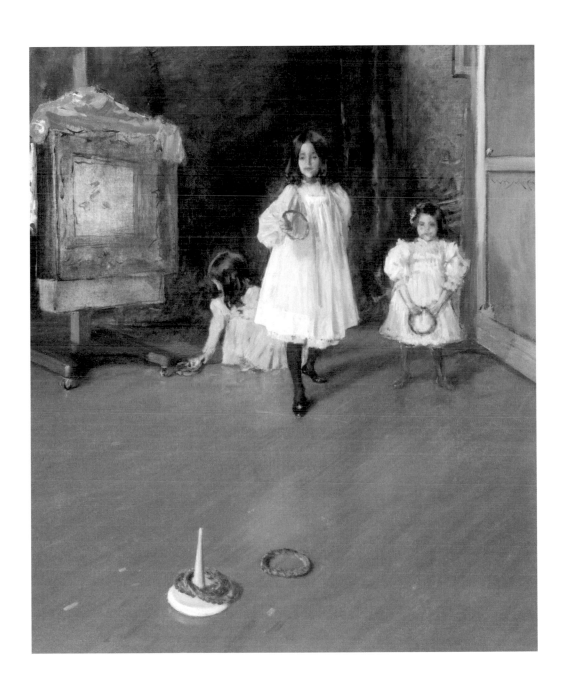

The Ring Toss, about 1896
Oil on canvas, 102.6 × 89.2 cm (40⅛ × 35⅛ in.)
The Halff Collection

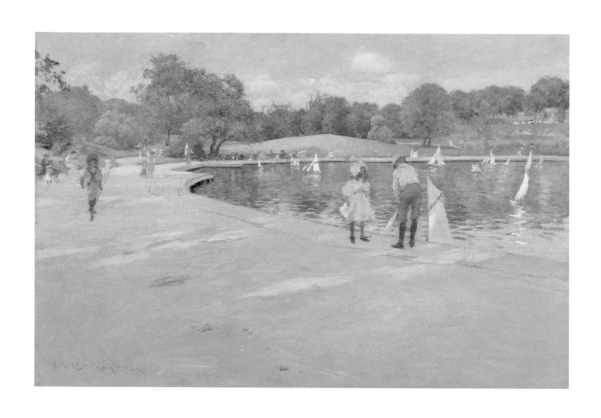

The Lake for Miniature Yachts, about 1888
Oil on canvas, 40.6 × 61 cm (16 × 24 in.)

Private collection

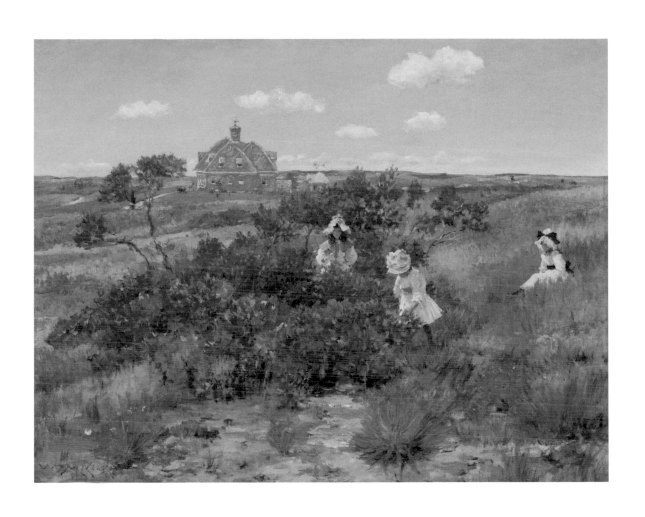

The Big Bayberry Bush, about 1895
Oil on canvas, 64.8 × 84.1 cm (25½ × 33⅛ in.)
Parrish Art Museum, Water Mill, NY; Gift of Mrs. Robert
Malcolm Littlejohn, Littlejohn Collection, 1961.5.5

Idle Hours

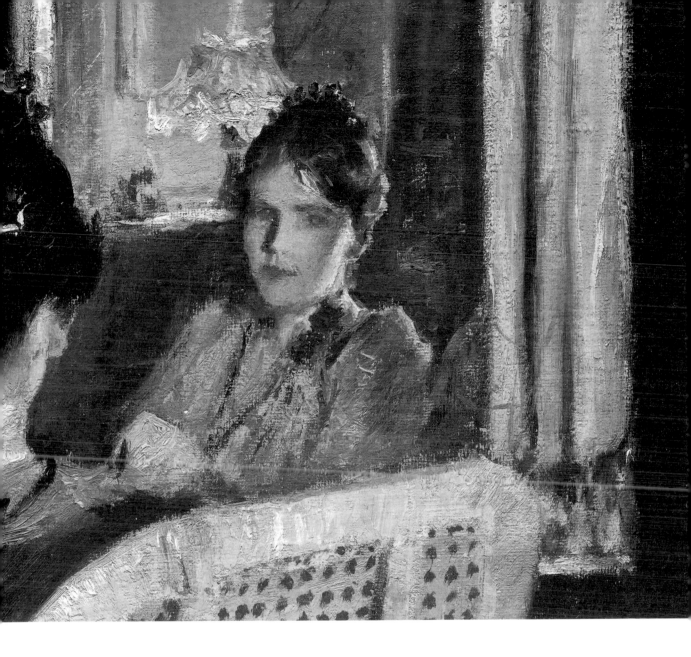

Industrious Americans once considered idle hands the devil's workshop, but spare time was reinvented in the late nineteenth century. "Leisure," remarked the social theorist Thorstein Veblen in 1899, had become "the chief mark of gentility."[1] Time away from work was celebrated as a reward of economic success, and (ironically perhaps) industries grew to support it, from the operation of elaborate mountain and seaside resorts to the manufacture of hammocks—once meant for laboring seamen, now a potent symbol of summer repose. Artists were also hard at work; while companions and models lounged in picturesque locations, they toiled, and exhibitions filled up with canvases

whose titles contained such phrases as "idle hours," *"dolce far niente"* (sweet doing nothing), "reflections," and "at ease." For a painter like Chase, as a writer for *Harper's* noted, "work is recreation and [his] recreation is work."[2] Chase recorded scenes of backyards and gardens, parks and parlors, quiet moments at home and abroad. One of America's most accomplished painters of leisure, he crafted alluring images of relaxation and respite with his characteristic technical fluidity—neither his subjects nor his handling of paint seems labored. His scenes conjure peaceful summer days and moments of quiet meditation; his carefully selected compositions and harmonious arrangements of color appear effortless.

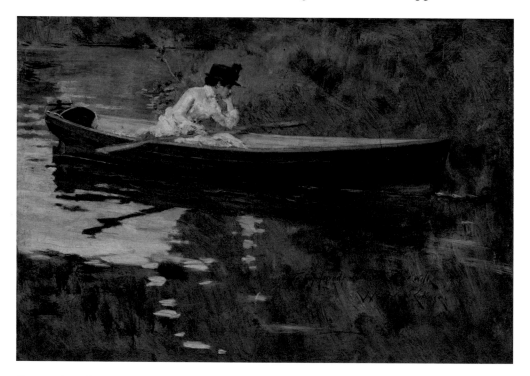

Figure 11. *Mrs. Chase in Prospect Park*, 1886

The summer season allowed families to enjoy expanses not only of time but also of space. Houses opened up to backyards that could become extra rooms. Chase's *Sunlight and Shadow* and *The Open Air Breakfast* both show this conflation of indoors and outdoors in garden settings, furnished with proper chairs and tables bearing linen and china; in each, a hammock provides a concession to the casual outdoor location. These spaces lie on the threshold between public and private. In the first scene, made in the Dutch seaside resort town of

Zandvoort and depicting Chase's friend the painter Robert Blum and a young lady in pink (with whom he may have been having a "tiff," the nickname Chase gave to the work), an older woman, dressed in black and hunched over her task, can be seen in the next yard. *The Open Air Breakfast* is set in the backyard of Chase's parents' home in Brooklyn; here too the presence of neighbors is signaled by the white-railed stairway of an adjacent house that appears just beyond the fence. Nature and nurture combine in these scenes, for while the participants are carefully garbed—buttoned collar, white summer suit, spats for the gentleman, and lace-trimmed gowns, shoes and stockings for the ladies— and the tables formally set, patches of sunlight filter through the abundant foliage, flowers bloom, and hammocks sway in the soft air. Blum smokes a cigarette and reaches for a cup in one scene, while in the other, Chase's sister Hattie holds a small racquet for playing shuttlecock, and his black dog lolls in the cool grass. These are moments of inaction and stasis, conducive to daydreaming: "Idleness opens up for any one who has eyes to see and a mind to dream a playground of infinite variety," according to one writer.[3] Such casual, non-narrative images also became the mark of a modern painter.

Mindful dreaming and contemplation were also among Chase's favorite subjects. Sometimes he caught his model alone with her thoughts in an outdoor setting, as he did in *Park Bench*. Here, on a sun-dappled seat in New York's Central Park, a woman has turned her attention away from the yellow-jacketed novel that lies in her lap. She adopts the classic pose of the thinker, chin resting on her hand, eyes open but gazing far beyond her immediate setting. The landscape of the mind is as potent for her as the surrounding scenery. Similarly, in *Mrs. Chase in Prospect Park*, Alice is lost in thought, her oars at rest, her thoughts perhaps as unmoored as the boat in which she drifts.

Most often, Chase celebrated such inner reflections in an interior setting. An introspective painting entitled *The Young Orphan*, which Chase also displayed with the less sentimental title *At Her Ease*, shows a young girl in black leaning into a red armchair, placed against a red curtain or wall. The famous example that inspired the costume, composition, and thinly applied pigment was James McNeill Whistler's portrait of his mother (*Arrangement in Black and Grey, No. 1*, 1871, Musée d'Orsay). Although Chase's model turns toward the viewer, her face remains a wistful cipher. If she is identified as an orphan, she seems plainly in mourning, her black dress and clutched handkerchief indicative of her grief.

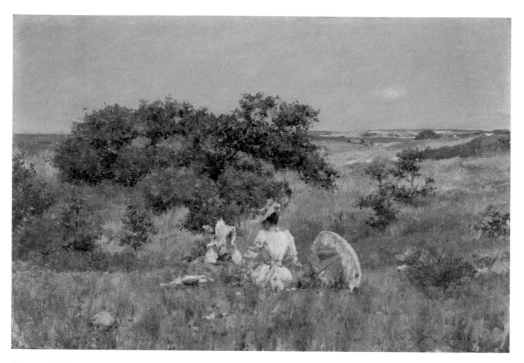

Figure 12. *The Fairy Tale*, 1892

Under the title *At Her Ease*, her heavy burden is lifted, allowing a more positive interpretation of her daydreams. Thus to one American writer she seemed to be a "young lady who is taking *dolce far niente*," while a Belgian critic especially admired "how this child thinks and dreams and abandons herself and relaxes there all beautiful and blond!"[4]

In his leisure scenes, Chase often counted on his family to pose. In *Tired*, Chase's daughter Cosy rests against a plump pink pillow. She is worn out, from play or from modeling for her father, her features glazed with exhaustion. While she rests, Chase is hard at work, delineating her delicate features with great care and laying down a bold flurry of thick, liquid strokes to define the pillow and Cosy's pink-striped dress. The pensive, doubly meaningful title *Reflections* belies the bold juxtaposition of black and gold that surrounds the artist's wife in another Shinnecock scene. Alice faces away from the viewer, but her reflection in the mirrored cupboard door is direct and engaging. She may be still, but her alert posture and Chase's gestural strokes imply movement and energy. Thinking was not necessarily indolence, as Chase demonstrated again in his large

pastel *In the Studio*, where Alice considers a sketchbook or journal. Rather than simply flipping through pages, having stopped idly on her way upstairs, she appears to be immersed in the thoughtful review of a connoisseur. As women in the late nineteenth century became knowledgeable consumers of culture and collectors of art, a visit to the studio could be much more than a social event.[5]

Chase often painted the sandy dunes of Shinnecock, where he and his family spent summers from 1891 to 1902 and where (in the midst of an active teaching schedule) his celebration of leisure reached its apogee. A writer for an art journal in 1894 declared: "The summer belongs to the artist by an inalienable right," and the south shore of eastern Long Island proved to be "an ideal camping place . . . where no one stares at you as you lug your paint-box and easel and stool."[6] *Idle Hours* encapsulates the joy of those seaside summers. Here Alice Chase, two of her daughters, and her sister sit motionless in the sun. Alice reads while one of the girls gazes up at the shifting clouds, her abandoned berry bucket adding a note of bright red to match her mother's hat and the decorative trim of the plump cushions. "Work is not the only good thing in the world," opined a writer for *Scribner's* in 1893. "Leisure has a value of its own. It has a distinct and honorable place wherever nations are released from the pressure of their first rude needs . . . and rise to happier levels of grace and intellectual repose."[7]

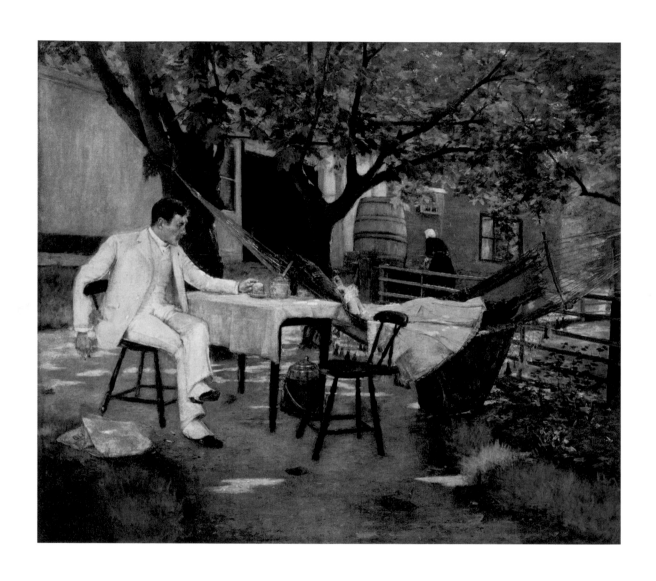

Sunlight and Shadow, 1884
Distemper on canvas, 165.7 × 197.5 cm (65¼ × 77¾ in.)
Joslyn Art Museum, Omaha, Nebraska; Gift of the Friends of Art Collection, 1932.4

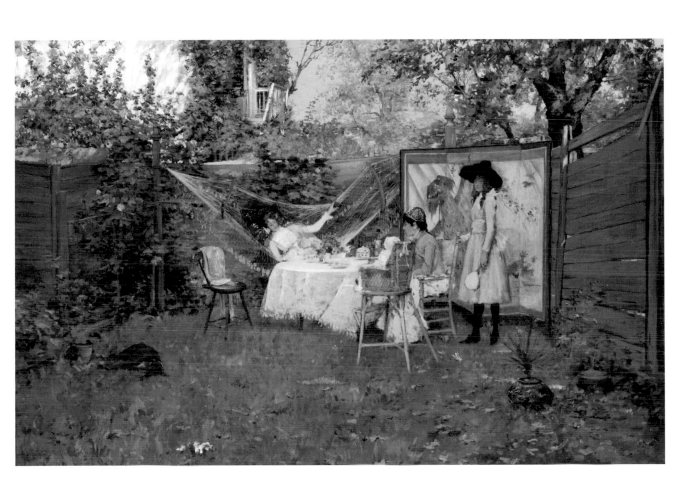

The Open Air Breakfast, about 1888
Oil on canvas, 95.1 × 144.1 cm (37⅜ × 56¾ in.)
Toledo Museum of Art; Purchased with funds from the Florence Scott
Libbey Bequest in Memory of Her Father, Maurice A. Scott, 1953.136

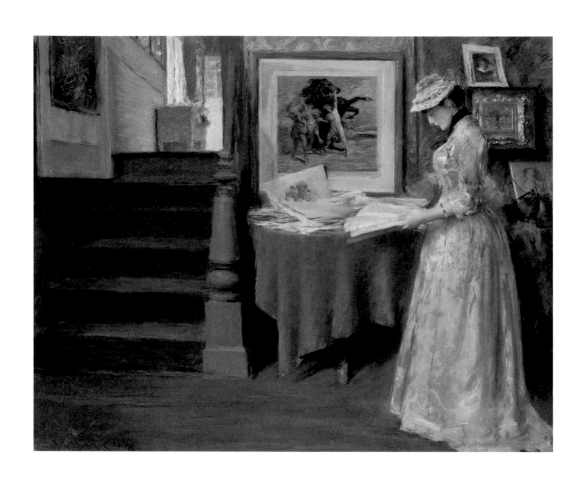

In the Studio, about 1892–93
Pastel on paperboard, 55.9 × 71.1 cm (22 × 28 in.)
Hirshhorn Museum and Sculpture Garden, Smithsonian Institution,
Washington, DC; Gift of Joseph H. Hirshhorn, 1966, 66.878

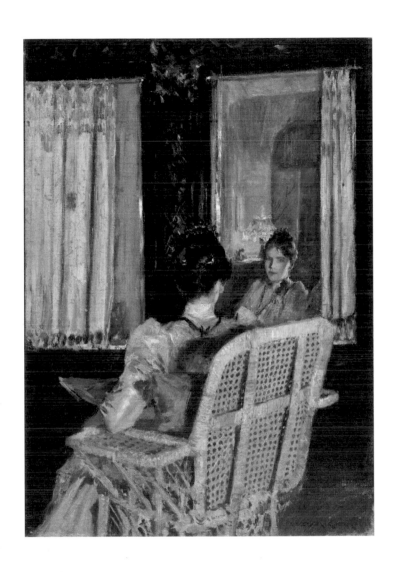

Reflections, about 1890
Oil on canvas, 55.9 × 40.6 cm (22 × 16 in.)
Private collection

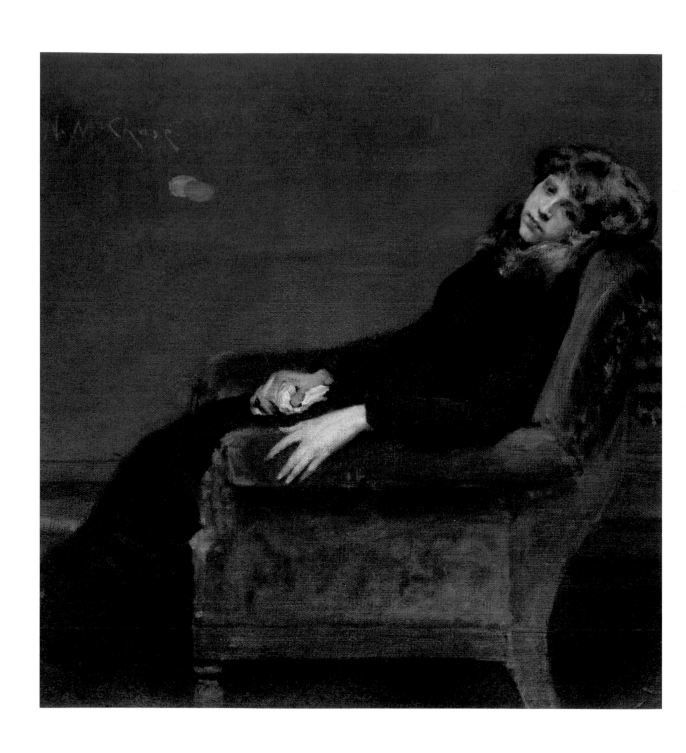

The Young Orphan, 1884
Oil on canvas, 111.8 × 106.7 cm (44 × 42 in.)
National Academy Museum, New York, 221-P

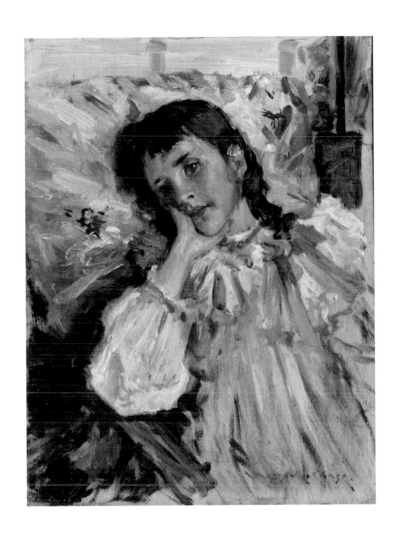

Tired, about 1894
Oil on panel, 33 × 24.1 cm (13 × 9½ in.)
Collection of Arthur and Lois Stainman

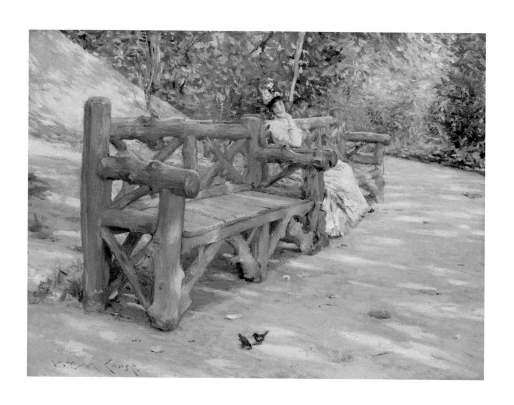

Park Bench, about 1890
Oil on canvas, 30.5 × 40.6 cm (12 × 16 in.)
Museum of Fine Arts, Boston; Gift of Arthur Wiesenberger, 1949, 49.1790

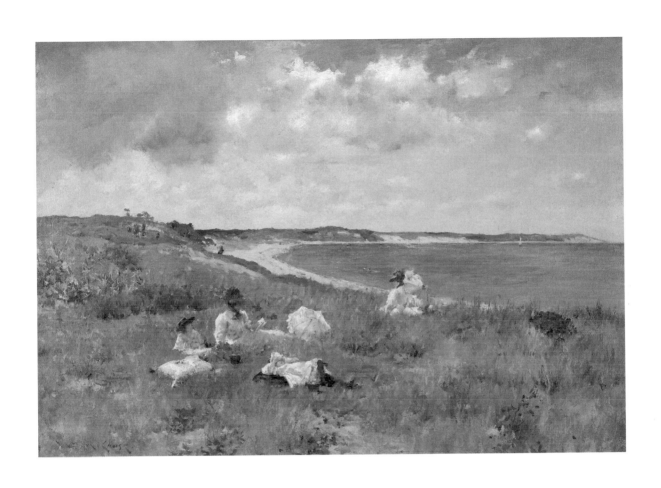

Idle Hours, about 1894
Oil on canvas, 64.8 × 90.2 cm (25½ × 35½ in.)
Amon Carter Museum of American Art, Fort Worth, Texas, 1982.1

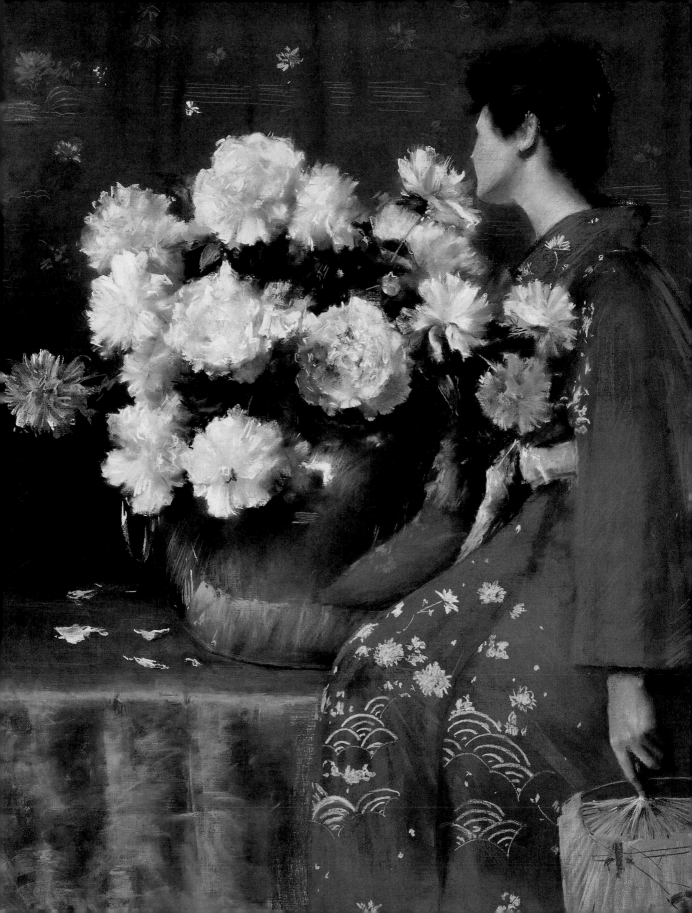

Notes

The Artist's World

1. "William M. Chase, Famous Artist, Dies," *The Washington Times*, October 26, 1916, p. 3.

2. Katharine Metcalf Roof, *The Life and Art of William Merritt Chase* (New York: Charles Scribner's Sons, 1917), 309

3. Georgia O'Keeffe, *Georgia O'Keeffe* (New York: Viking Press, 1976), n.p.

Studio as Theater

1. Elizabeth Williams Champney, *Witch Winnie's Studio* (New York: Dodd, Mead, and Company, 1892), 18.

2. "The William Merritt Chase Exhibition," *Art Amateur* 16 (April 1887): 100; James McNeill Whistler, *The Gentle Art of Making Enemies*, 2nd ed. (London and New York: William Heinemann, 1892), 184–85.

3. Katharine Metcalf Roof, *The Life and Art of William Merritt Chase* (New York: Charles Scribner's Sons, 1917), 51. For the Tenth Street Studio, see Annette Blaugrund, *The Tenth Street Studio Building: Artist-Entrepreneurs from the Hudson River School to the American Impressionists*, exh. cat. (Southampton, NY: Parrish Art Museum, 1997).

4. See Nicolai Cikovsky, Jr., "William Merritt Chase's Tenth Street Studio," *Archives of American Art Journal* 16, no. 2 (1976): 2–14. See also Bruce Weber and Sarah Kate Gillespie, *Chase Inside and Out: The Aesthetic Interiors of William Merritt Chase* (New York: Berry-Hill Galleries, 2004).

5. Elliot Daingerfield, *Paintings by William Merritt Chase NA* (New York: Newhouse Galleries, 1927), and W. A. Cooper, "Artists in Their Studios," *Godey's Magazine* 130 (1895): 291, both as quoted in Cikovsky, "William Merritt Chase's Tenth Street Studio," 8.

Modern Women

1. Julia A. Sprague, *History of the New England Women's Club from 1868 to 1893* (Boston: Lee and Shepard, 1894), 1–2. See also Holly Pyne Connor, ed., *Off the Pedestal: New Women in the Art of Homer, Chase, and Sargent* (Newark, NJ: The Newark Museum, 2006). For Chase and his images of women, see Erica E. Hirshler, "Old Masters Meet New Women," in *William Merritt Chase: A Modern Master*, by Elsa Smithgall et al. (Washington, DC: The Phillips Collection; New Haven: Yale University Press, 2016).

2. William Wetmore Story, to John Russell Lowell, February 11, 1853, in Henry James, *William Wetmore Story and His Friends* (Edinburgh: William Blackwood and Sons, 1903), vol. 1, 255.

3. For some of the complexities of this discussion, see Kathy Peiss, "Going Public: Women in Nineteenth-Century Cultural History," *American Literary History* 3 (Winter 1991): 817–28.

4. See Barbara Dayer Gallati, *William Merritt Chase: Modern American Landscapes, 1886–1890* (Brooklyn: Brooklyn Museum of Art, 1999), 72–78.

5. "The Women Are Thinking about It," *Chicago Tribune*, August 24, 1885, p. 8.

6. For Dora Wheeler, see Karal Ann Marling, "Portrait of the Artist as a Young Woman: Miss Dora Wheeler," *The Bulletin of the Cleveland Museum of Art* 65 (February 1978): 47–57, and Amelia Peck, *Candace Wheeler: The Art and Enterprise of American Design, 1875–1900* (New York: Metropolitan Museum of Art, 2001), 174–78. For Emmet, see Tara Leigh Tappert, *The Emmets: A Generation of Gifted Women* (New York: Borghi and Co., 1993).

7. "Portraits by Wm. M. Chase," *New York Times*, April 9, 1901, p. 9.

Japonisme

1. Karl Baedeker, *Southern Germany and Austria: Handbook for Travellers* (Koblenz and Leipzig, 1873), 81.

2. Julia Meech Pekarik, "Early Collectors of Japanese Prints and The Metropolitan Museum of Art," *Metropolitan Museum Journal* 17 (1984): 107–9. For the Tile Club, see Ronald G. Pisano, *The Tile Club and the Aesthetic Movement in America* (New York: Abrams, 1999).

3. Chase, Lecture Notes and Speeches, William Merritt Chase Papers, Archives of American Art, Smithsonian Institution, Washington, DC, roll N-69-137: 474. See also Linda Merrill et al., *After Whistler: The Artist and His Influence on American Painting* (New Haven: Yale University Press, 2003).

4. Alfred Trumble, "An Artist's Collection," *The Collector* 2 (December 1890): 32.

5. See the discussion in William Hosley, *The Japan Idea: Art and Life in Victorian America* (Hartford, CT: Wadsworth Atheneum, 1990).

6. Koto House was the adopted daughter of the foreign journalist Edward H. House and served as Koto Chase's godmother. See "A Child of Japan," *Current Literature* 11 (October 1892): 152. For the complete story, see James L. Huffman, *A Yankee in Meiji Japan: The Crusading Journalist Edward H. House* (Lanham, MD: Rowman and Littlefield, 2003). Chase later bestowed a similar honor on Spain, naming his fifth daughter Helen Velasquez.

7. "Professors of Pastels," *New York Times*, May 5, 1888, p. 4.

8. Henry James to Thomas Sergeant Perry, September 20, [1867], in *Henry James Letters*, ed. Leon Edel (Cambridge, MA: Harvard University Press, 1974), vol. I, 77.

Child's Play

1. William Newell, *Games and Songs of American Children* (New York: Harper and Bros., 1884), 12. See also Howard P. Chudacoff,

Children at Play: An American History (New York: New York University Press, 2007).

2. Lina Beard and Adelia B. Beard, *The American Girls Handy Book* (1887; rept., Boston: David R. Godine, 1987), 29–30.

3. Cynthia P. Dozier, "The Children at the Seashore and on the Mountains," *The Outlook* 54 (July 18, 1896): 97–98.

4. For further information, see Ingrid Schaeffer et al., *About "The Bayberry Bush"* (Southampton, NY: Parrish Art Museum, 2001).

5. Arthur Wakely, "The Playground of the Metropolis," *Munsey's Magazine* 13 (September 1895): 570.

Idle Hours

1. Thorstein Veblen, *The Theory of the Leisure Class* (1899; New York: Macmillan, 1912), 55.

2. John Gilmer Speed, "An Artist's Summer Vacation," *Harper's New Monthly Magazine* 87 (June 1893): 3.

3. Arthur Stanwood Pier, "Work and Play," *Atlantic Monthly* 94 (November 1904): 670.

4. L. G. Sellstedt, "The Chase Exhibition," unidentified clipping, 1891, as quoted in Ronald G. Pisano, *William Merritt Chase: Portraits in Oil* (New Haven: Yale University Press, 2006), 54; Émile Verhaeren, "Chronique Artistique. II. Exposition Des XX," *La Jeune Belgique* 3 (March 15, 1884): 243, as quoted in John Davis, "Chase's International Style," in *William Merritt Chase: A Modern Master* by Elsa Smithgall et al. (Washington, DC: The Phillips Collection; New Haven: Yale University Press, 2016), 56. See also the discussion in Bruce Weber and Sarah Kate Gillespie, *Chase Inside and Out: The Aesthetic Interiors of William Merritt Chase* (New York: Berry-Hill Galleries, 2004).

5. See Sarah Burns, *Inventing the Modern Artist: Art and Culture in Gilded Age America* (New Haven: Yale University Press, 1996); Kathleen D. McCarthy, *Women's Culture: American Philanthropy and Art, 1830–1930* (Chicago: University of Chicago Press, 1991);

and Dianne Sachko Macleod, *Enchanted Lives, Enchanted Objects: American Women Collectors and the Making of Culture 1800–1940* (Berkeley: University of California Press, 2008).

6. Alfred Trumble, "Art's Summer Outings," *The Quarterly Illustrator* 2 (October–December 1894): 377, 385, 392.

7. Agnes Repplier, "Leisure," *Scribner's Magazine* 14 (July 1893): 63, 64.

Figure Illustrations

Works are by William Merritt Chase unless otherwise noted.

1
George Collins Cox (1851–1902)
William Merritt Chase in His Studio at 51 West 10th Street, about 1879–83
Photograph
Collection of the Museum of the City of New York

2
Unknown photographer
William Merritt Chase, Mary Content, and Roland, Shinnecock Hills, about 1905
Cyanotype, 5.7 x 3.5 cm (2¼ x 1⅜ in.)
The William Merritt Chase Archives, Parrish Art Museum, Water Mill, NY
Gift of Jackson Chase Storm, 83.stm.74

3
Unknown photographer
William Merritt Chase in His Tenth Street Studio, about 1895
Gelatin silver print, 15.2 x 9.5 cm (6 x 3¾ in.)
The William Merritt Chase Archives, Parrish Art Museum, Water Mill, NY
Gift of Mary M. Cross, 75.C.4

4
A Friendly Call, 1895
Oil on canvas, 76.5 x 122.5 cm (30⅛ x 48¼ in.)
National Gallery of Art, Washington, DC
Chester Dale Collection, 1943.1.2

5
Charles Allan Gilbert (1873–1929)
Wellesley College Illustrated in the May Scribner's, 1898
Color lithograph, 57 x 35 cm (22½ x 13¾ in.)
Boston Public Library

6
Lady in Black, 1888
Oil on canvas, 188.6 x 92.2 cm (74¼ x 36¼ in.)
The Metropolitan Museum of Art, New York
Gift of William Merritt Chase, 1891, 91.11
Image copyright © The Metropolitan Museum of Art. Image source: Art Resource, NY

7
The Kimono, about 1895
Oil on canvas, 89.5 x 115 cm (35¼ x 45¼ in.)
Museo Thyssen-Bornemisza, Madrid, 1979.24
Museo Thyssen-Bornemisza/Scala/Art Resource, NY

8
James McNeill Whistler (1834–1903)
The Princess from the Land of Porcelain (La Princesse du pays de la porcelaine), 1863–65
Oil on canvas, 201.5 x 116.1 cm (79⅜ x 45¾ in.)
Freer Gallery of Art, Washington, DC
Gift of Charles Lang Freer, F1903.91a-b
Freer Gallery of Art, Washington/HIP/Art Resource, NY

9
At the Seaside, about 1892
Oil on canvas, 50.8 x 86.4 cm (20 x 34 in.)
The Metropolitan Museum of Art, New York
Bequest of Miss Adelaide Milton de Groot (1876–1967), 1967, 67.187.123
Image copyright © The Metropolitan Museum of Art. Image source: Art Resource, NY

10
In the Park (A By-Path), about 1889
Oil on canvas, 35.5 x 49 cm (14 x 19¼ in.)
Museo Thyssen-Bornemisza, Madrid
Carmen Thyssen-Bornemisza Collection, CTB.1979.15
© Colección Carmen Thyssen-Bornemisza, Museo Thyssen-Bornemisza/Scala/Art Resource, NY

11
Mrs. Chase in Prospect Park, 1886
Oil on panel, 34.9 x 49.9 cm (13¾ x 19⅝ in.)
The Metropolitan Museum of Art, New York
The Chester Dale Collection, Bequest of Chester Dale, 1963, 63.138.2
Image copyright © The Metropolitan Museum of Art. Image source: Art Resource, NY

12
The Fairy Tale, 1892
Oil on canvas, 41.9 x 61 cm (16½ x 24 in.)
Private collection

Illustration Credits

Acknowledgments

Just as William Merritt Chase worked in the congenial art village of Southampton, NY, I have worked in my own art village, encompassing many colleagues throughout the field without whose help this project would never have been completed. This volume complements the catalogue *William Merritt Chase: A Modern Master* (Washington, DC: The Phillips Collection; New Haven: Yale University Press, 2016), which accompanies the exhibition organized by The Phillips Collection, Washington, DC; the Museum of Fine Arts, Boston; Fondazione Musei Civici di Venezia; and the Terra Foundation for American Art. The creativity, insight, and research skills of Kelsey Gustin and Alexander Ciesielski, both Boston University graduate student interns at the MFA, have been invaluable to me for both the conception and the implementation of this book; it simply would not exist without them. To the owners of the exquisite works illustrated here, and to their assistants and staff, I offer my deepest gratitude for their kindness in making illustrations available for this publication. I am especially beholden to my generous colleagues at The Phillips Collection, Elsa Smithgall and Kathryn Rogge, for their gracious aid at a crucial moment, as well as to Fred Baker, Alicia Longwell, and Fronia Simpson. At the MFA, I would like to thank Elliot Bostwick Davis, John Moors Cabot Chair, Art of the Americas, and Emiko K. Usui, Director of MFA Publications, for their encouragement and enthusiasm; Anne Nishimura Morse, William and Helen Pounds Senior Curator of Japanese Art, for her careful review of the chapter on Japonisme; Jennifer Snodgrass, Senior Editor, for her skill and patience; and Steven Schoenfelder for the book's elegant design. Generous support for this publication was provided by the Ann and William Elfers Publications Fund. As this project demanded more than the usual number of weekend hours, I owe even more than ever to my dear husband, Harry Clark.

Erica E. Hirshler
Croll Senior Curator of American Paintings, Art of the Americas
Museum of Fine Arts, Boston

Index of Artworks

mfa BOSTON

MFA Publications
Museum of Fine Arts, Boston
465 Huntington Avenue
Boston, Massachusetts 02115
www.mfa.org/publications

Generous support for this publication
was provided by the Ann and William Elfers
Publications Fund.

ISBN 978-0-87846-839-3
Library of Congress Control Number:
2015955014

While the objects in this publication neces-
sarily represent only a small portion of the
MFA's holdings, the Museum is proud to be
a leader within the American museum com-
munity in sharing the objects in its collection
via its website. Currently, information about
more than 330,000 objects is available to
the public worldwide. To learn more about
the MFA's collections, including provenance,
publication, and exhibition history, kindly
visit www.mfa.org/collections.

For a complete listing of MFA publications,
please contact the publisher at the above
address, or call 617 369 3438.

Grateful acknowledgment is made to the
copyright holders for permission to repro-
duce the works listed on p. 81.

Edited by Jennifer Snodgrass
Proofread by Fronia W. Simpson
Designed by Steven Schoenfelder
Production by Terry McAweeney
Production assistance by Hope Stockton
Printed and bound at Graphicom,
Verona, Italy

Distributed in the United States of
America and Canada by
ARTBOOK | D.A.P.
155 Sixth Avenue
New York, New York 10013
www.artbook.com

Distributed outside the United States of
America and Canada by
Thames & Hudson, Ltd.
181A High Holborn
London WC1V 7QX
www.thamesandhudson.com

FIRST EDITION
Printed and bound in Italy
This book was printed on acid-free paper.